TALES OF
LONDON'S DOCKLANDS

'THE DAILY WORKING EXPERIENCES OF LIFE IN
THE DOCKLANDS OF THE PORT OF LONDON'
FOR DOCKERS, STEVEDORES, O.S.T. CLERKS,
& LIGHTER-MEN.

TALES OF
LONDON'S DOCKLANDS

HENRY T. BRADFORD

AMBERLEY

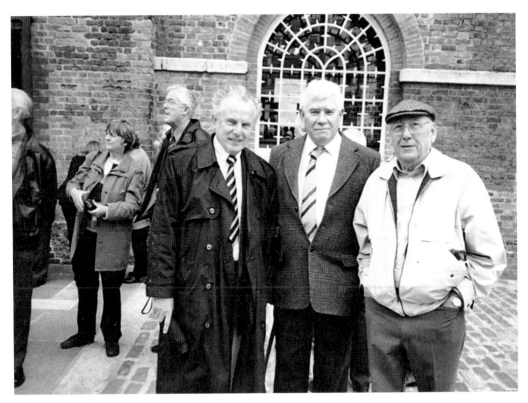

The author (centre) with two former 'Ship's Clerk colleagues' at the opening of The Museum in Docklands, West India Docks, London, 19 May 2003.

First published 2010

Amberley Publishing
Cirencester Road, Chalford,
Stroud, Gloucestershire, GL6 8PE

www.amberley-books.com

British Library Cataloguing in Publication Data.
A catalogue record for this book is available from the British Library.

ISBN 978-1-4456-0166-3

Typeset in 10pt on 12pt Sabon.
Typesetting and Origination by Amberley Publishing.
Printed in the UK.

CONTENTS

ACKNOWLEDGEMENTS

I wish to take this opportunity to thank my friends Philip Connolly, Valerie Thomas and Derek Cooper, for preparing the photographs, and for the technical assistance that came with presenting the material for publication of this book of tales in today's publishing environment.

Of course it goes without saying my thanks extend beyond the grave to my late workmates of yester-year in the docklands of the Port of London, whose names I have changed to save any embarrassment that may be felt by any relative who may come to read these tales.

However, as a member of that fraternal band of workmates, I feel only pride in having known and worked with such men, listened to and mentally recorded their stories, and lived long enough to record them for posterity – God bless them now wherever they me be.

Henry T. Bradford

INTRODUCTION

The stories included in this composition are based on the author's personal knowledge, and his participation in dock work, dock work ethics, and recognised dock work antics as they are described in these London dockland tales. That is they are records from the author's experiences of yester-years.

The author is also well aware that it may be difficult for some non-members of the docklands and riverside working communities, to understand the how, the what, and the wherefore of such a complex industry. In particular with regards to the fact that Registered Dock Workers were taken on for a work operation that could last four hours, several days, or several weeks. A work period after which they would be returned to the Dock Labour Compound for re-employment, re-deployment, or unemployment that could also stretch over a period of four hours, many days, or even many weeks. This unfortunate phenomenon was due, in no short measure, to the vagaries of the shipping industries ocean trading, cargo passenger liner, and passenger liner sailing schedules; and lackadaisically planned tramp steamer and short sea trading contracted cargo delivery schedules.

Of course, this state of uncertainty in employment meant there grew a close sense of camaraderie among Registered Dock Workers. This was further fostered by news media's continual admonishment of them and their work. Such adverse industrial propaganda only aided in inducing anti-employer activities, further aided by high casualty rates, long hours of work, and discrimination in job opportunities, especially against those injured men who had returned to the industry as category 'C' men. This is a stark fact the author can vouch for, from personal experiences.

It is, therefore, the author's intention that the tales included in this book have been purposely set out to cover the wider aspect of his working experience, together with his personal knowledge that was gained from thirty-two years of employment in the docklands of the Port of London. In this time he worked as a docker, a down hold foreman, a crane driver/winch driver, an assistant ship worker, an O.S.T. clerk, and a ship's clerk, before retiring from the port transport industry due to injuries sustained in dockland accidents.

FOREWORD
By Mr John N. Black

Henry Bradford has produced an excellent book that depicts the life and characteristics of Registered London Dock Workers. With his vast and direct experience of all aspects of the docker's work and background, he has managed in his books to bring to life the harshness, brutality, and poverty encountered in the early days of working in the dock industry. This has been enhanced by means of the various stories he has obtained from the 'old codgers' he worked with. However, as Mr Bradford has indicated in his narratives, not everything was bad in the work of the dockers – humour was always present and camaraderie among the men shined through.

Henry's excellent preface describes the background to the industry, and the cruel procedures associated with obtaining work in the early days. The creation of the National Dock Labour Board (NDLB), while it was responsible for improving the allocation of work within ports, also brought dock workers onto a register which guaranteed them employment as dockers, even though this often meant earnings were limited to full back guarantee pay when work was short. (The 'full back guarantee' was paid through the NDLB, from monies deducted from previous registered dock-workers earnings, at varying rates, levied from port employers at between 15 per cent and 17.5 per cent of gross earnings.)

With the introduction of permanent registration for the employment of dock workers (which allowed dockers, stevedores and tally clerks to be employed by, or allocated to, different employers), was an astute move in that it gave dock worker employees an identity that they had not previously had (this was before the introduction of the Dock Workers (Regulation) Of Employment Act 1947/48). A later introduction to permanent employment under Devlin Phase II, went further. In so far that it allowed companies associated predominantly with imported cargo, such as packaged timber and containers, to take over responsibility to operate their own ship berths, and employ their own workers. This led to a far better relationship between employers and employees.

The advent of containerisation revolutionised dock-working conditions, closed down the Upper Docks of the Port of London, and led to difficult industrial disputes before settling down. From a total of some 67,000 registered workers in 1962, there has been a reduction of some 90 per cent over the last 50 years, even though the total tonnage of cargo imported and exported through the Port of London remains in excess of 50 million tons per annum.

Mr Bradford may like to consider writing sequels to his excellent books, and look at the more recent changes in the industry.

Meanwhile I can thoroughly recommend Henry Bradford's book *Tales of London's Docklands*, which should be enjoyed and handed down as valuable additions to the history and culture of these islands of ours.

John N. Black
Former Deputy Chairman and Chief Executive, The Port of London Authority.

TALE 1
Big Dave and Colonel, 'What! What!'

Big Dave was standing by a Port of London Authority Mobile Tea Van. Mobile Tea Vans had been introduced into Port of London docks during the Second World War, by courtesy of an American organisation that had been appalled at such a lack of the most rudimentary welfare provisions for dock workers, in the busiest and richest port on this Earth. Before this simple revolutionary welfare idea had been introduced in the docks of the Port of London, young boys had been employed to collect money from dockers and stevedores while they were working, to buy beer for them to drink during their (on the job) work breaks; hence the cry before, and even after the advent of Mobile Tea Vans for work breaks was, 'Beer Ho'.

Big Dave (to be known henceforth as Dave), a lugubrious 159 kilo (25 stone), 197 cm (6 foot 6 inch) tall giant of a man, was standing next to last in the Mobile Tea Van queue. When it came to his turn to be served he asked the Tea Lady (all Mobile Tea Van women drivers were known in the docks as Tea Ladies) for a mug of tea with two slices of bread and beef dripping with salt. Betty (better known among the docking fraternity as 'Beautiful Betty', because to be truthful, she was a real 'Plain Jane' if ever there was one) asked Dave if he was on a diet, because Dave usually bought four slices of bread, beef dripping and a double chunk of bread pudding. However, Eddy L., Dave's workmate and mentor, who was standing behind Dave in the queue, promptly interjected, 'He's in training, Betty. He's got to cut back on all that pap he's been gorging himself on. I've got to toughen him up.' he said.

Betty raised her eyebrows, smiled at Dave, then winked at him before saying, 'He looks in fine shape to me just as he is.'

'No Betty, you should know better than most people that looks can be deceptive. There's far too much flab on him. Look at his waistline. When he lies down, his stomach sticks up in the air like the Mountains of Mourne as they sweep down to his knees. I'm getting him back into full training for a wrestling match, aren't I Dave!'

'You're doing what?' said Betty as she burst out laughing. 'Big Dave wrestling! I'll believe that when I see that with my own eyes.'

Dave stood looking at her with a dead-pan face. There was not a blemish of a smile to be seen.

'Tell her Dave,' said Eddy L.

'Tell me what?' Betty retorted.

'Tell her how I trained you to become the heavyweight wrestling champion of India. Go on, Dave. Show Betty your biceps.'

Dave bent his left knee, and flexed his right wrist up towards his elbow. A large muscle appeared on his upper arm, a bulge that looked like a rugby ball being held in an elephant's trunk. Eddy L. invited Betty to, 'Feel that for a muscle!'

Betty ran her hand down Dave's upper and forearm. Then she smiled up at him, before raising her eyebrows even higher than she had previously. Then she said:

'It's a pity we're not alone, David.' She winked at him again before continuing, 'I could get rid of some of those bulging muscles for you, without your having to starve or exert yourself, darling.'

'You can cut that out, madam,' said Eddy L. airily, 'I told you, he's in training.'

'Yes,' replied Betty, 'so you've told me several times. Heavyweight wrestling champion of India, wasn't it. Eh! Some hope.'

'You tell her what happened Dave, when we were shipped out to India with the army in 1942. Go on mate, you can tell her, she doesn't believe me.'

Dave's usual deadpan face creased into a broad grin.

'Well then,' Dave began, 'it was like this. We arrived in transit near to Calcutta, on our way to Burma to join up with the 14th Army. A vast camp of canvas tents had been set up for our battalion's use, on the outskirts of the Calcutta city limits. The official orders were to sleep under canvas, till road or rail transport was made available to take us on to Dacca. We'd been travelling for weeks since we had left England. Troop ships were having to be diverted away from the Mediterranean Sea and the Suez Canal route to India, for what was thought to be a safer sea passage down the West Coast of Africa, into the South Atlantic, round the Cape of Good Hope, and into the Bay of Bengal via the Indian Ocean, so as to dock ships in safety, then disembark we soldiers. But by the time we had arrived at what was to be our first transit camp site, before going on to Burma, we troops with very few exceptions, had become extremely tired, bored to the point of tears, and fed up to their back teeth. In other words discipline was breaking down.

'However, our Colonel, known to we troops as "The Hon. Colonel What-What", had had an idea that some of the troops called a brain wave. That in itself was a phenomenon that puzzled and perplexed not a few of us common conscripted soldiers. But not the Regulars Soldiers among us, who were apparently used to such runs of hot blood into their Colonel's otherwise bullet proof head. For we had no idea our Colonel had enough grey brain cells in his ample skull for him to have had a brain wave with. Well least not on his very own initiative. However, it appeared that during this alleged brain wave the Hon. Colonel had decided that what we travel weary, bored to death troops really needed to enliven us for battles yet to come was a large dose of gory, blood thirsty entertainment. The Colonel therefore ordered Captain Pratt-Morton, the Regiment's Entertainments Officer, to: "Organise a bit of innocent fun entertainment, something along those lines."

'The next day I was ordered by Captain Pratt-Morton, to present myself before our illustrious leader, "The Right Hon. Colonel What-What."

'When I'd come to attention in front of him, and saluted, the Hon. Colonel said: "I understand *Private*," he fully emphasised the *Private* bit, so as to let me know he was in charge, "you were a schoolboy pugilist, a boxer so I understand."

'Then, before I had a chance to refute his slanderous claim about my fisticuff prowess or boxing ability, he continued, "I've got your civvy records here. A senior schoolboy-boxing champion for Kent 1928 and 1930, wasn't it? Good show that, What-What!"

'"Yes sir," I replied without enthusiasm, and waited for his next witticism.

'"Well then, Captain Pratt-Morton our Entertainments Officer has arranged a sporting bout, a wrestling contest so I've been advised. Got some Indian fellow, 'bout your size so I've been lead to believe, but that shouldn't present you with much of a problem. You'd better get out there and show him what's what, What-What!" Dismiss. Then it was, "bout turn, by your left, quick march, left right, left right," from the Sergeant Major, as I was hustled out of the colonel's office.'

'Then what happened?' Betty asked.

'I was marched over to the Quartermasters store to be kitted out with some fighting togs. But the Quartermaster Sergeant had no boxing shorts that fitted me, so he got our camp tailor, Solly Wiseman, to run up a pair of cut-down sort of pantaloons for me. I must have looked a right idiot.'

'Yes, I can vouch for that, Dave,' said Eddy L. laughing. 'A right fairy you looked.' Then, with a wry smile on his face he said, 'all you needed was a wand.'

'Watch your tongue, you cheeky little man, while you've still got one.' Then he slashed his hands about a couple of times, in karate chops, before adding, 'I'm in training. Anyway,' he continued. 'It was on the following day, the day that had been set for the great wrestling tournament. Eddy and I made our way towards a wrestling ring they had set up. Well, it wasn't a ring as such, it was the whole bloody battalion drawn up in a square, with a hollow bit left in the centre for two contestants to perform in. Now you will correct me Eddy, if I go wrong, won't you! Well, Eddy and I walked down the narrow pathway, that had been left for us wrestlers and our seconds, to get into what had been rigged up to act as the wrestling ring. That was when I was stopped in my tracks, by what I thought was an oversized replica of the Buddha. It was squatting on the ground at the far edge of a sea of khaki clad soldiers, dressed all over in black, with a matching black robe over its shoulders. It had a large round head with jet-black hair; hair that was combed up to the top of its head into a bun. It had a round face with green, little piggy eyes, that shone like polished jade, eyes that drilled into me like some invisible auger. Its huge arms hung down its sides, like the boughs of an old yew tree in an English country churchyard. It had two thick legs that ran down from its knobby knees to its ankles, and a fat paunchy stomach that bulged out from its navel to its knees. In fact the stomach protruded so much towards its knees; it appeared not to have any tops to its legs at all. Then it blinked. "Good God, Eddy," I said, "that bloody things alive. I'm sure I saw it move." Now Eddy here had been detailed to act as my second. He looked up at me with those quizzical little crafty, beady eyes of his and said, "Don't you worry yourself about that, David. The Colonel ordered me to tell you to go out there and show him whose boss."

'I had looked down at Eddy here. Now didn't I look down at you and say, "If I had that bloody Hon. Colonel What-What here with me right now I'd damn soon show him who is the boss."'

'You did, David. Yes you did say that, or words to that effect,' agreed Eddy L.

'Yes I did,' said Dave, 'but then the army lads started to sing and shout and yell out:

"Why are we waiting, don't sod about, Dave. Get stuck into him."

'I made for my corner followed by Eddy here. Eddie my trusted friend, mentor and second. He had a towel and a sponge in one hand, and a bucket of water in the other.

'"What have you got those things for?" I asked him.

'"Seconds always carry these things," he'd replied, "I've seen them on the pictures." Then he said, "He looks placid enough to me, he does."

'I was thinking: he looks more like a sumo wrestler to me. If he grabs hold of me he'll kill me, I'm sure; so I devised a cunning plan that I knew would be my only salvation, and save me from certain death. So I waited patiently for the match to start, as into the ring strode our ebullient Entertainments Officer, Captain Pratt-Morton, who was bursting with enthusiasm at the prospect of some bloodletting, and a few broken bones. That was of course, provided it was somebody else's blood and bones, and not his own.

'"The Hon. Colonel," he called out fervently through a megaphone to the closely assembled throng, "is proud to present a one fall wrestling contest, to be fought over eight three minute rounds, between the Heavyweight Wrestling Champion of India, Mohammed 'Killer' Khan, and his British army opponent from our own battalion, private 393528 David M. Good luck to both of you, and may the best man win."

'Now, nobody had bothered even to mention anything to me about a wrestling champion, let alone the Heavy Weight Wrestling Champion of India.

'"Did you know anything about this Wrestling Champion of India prank, Eddy?" I did ask you that question, didn't I Eddy. What was your reply?

'You said, "The Hon. Colonel did mention something about it, but he said I shouldn't worry you about any minor details," and I replied,

'"You think that bloody Buddha squatting over there is a minor detail! I'm rather vexed with you, Eddy," I said. Didn't I say that to you?'

'Well. Not quite in those words, Dave. If I remember rightly I think you said. "If I get out of this damn mess alive, Eddy, I'm going to bloody kill you." That's what you actually said.'

Dave scratched his head before he replied, 'I wonder what made me forget a small detail like that.' He then continued:

'They couldn't find a bell to start the Wrestling Tournament. So the Battalion's cook was given the job as the "official time keeper". Then, when it was time to start the contest, the cook held up an empty steel slops bucket, which he struck with a soup ladle. That was the signal for the wrestling match to begin. It was then that bloody Buddha got up and began to move. Its piggy green eyes began X-raying me. It scanned me up and down. Its brain, I knew, was calculating my height and weight, so; I stood stock-still where I was, glued to my spot. I was not giving it a chance to calculate anything about me other than what it could already see. Finally, like a Praying Mantis, it began to move very slowly towards me until it got to the centre of the ring. Eddy here kept egging me on to "go at it", but I waited. Then the lads began barking insults, still I waited. Then the Buddha impressionist quite suddenly made a quick move towards me. It moved quite fast for a body of its size, as though it was on wheels; but it was not as fast as me. I had calculated it weighed at about eighteen stone; I weighed about twenty stone those days. The distance between us had narrowed to about ten feet when I rushed at it. I threw myself crossways across the top of its chest, grabbing its left arm as it toppled backwards onto the ground. At the same time I locked my legs round its right arm. I knew I had knocked the wind out of it, and as it laid gasping for breath, I locked my arms under its back and held on like grim death. It tried its hardest to throw me off, but it couldn't lift my twenty stone. Our PTI (physical training instructor), who was acting as the official referee, tried hard to push his hand under its shoulders, but he couldn't. So he counted the obligatory 'one, two, three,' and stopped the bout. Then he raised my hand, somewhat reluctantly I thought, and declared me to be the winner. That was how I became the uncrowned Heavy Weight Wrestling Champion of India.'

Dave then raised himself up to his full height of six foot six inches. He stretched his huge arms above his head. He flexed his biceps and said,

'And that Betty was how I did it.'

'Well, I'm ready to take you on for a wrestle any time you like, David,' and winking at him said, 'and don't kid yourself you'd beat me.'

'Cut that out Betty,' Eddy L. told her. 'You know he's in training.'

'What for! A Wrestling Match at his age? I'll believe that when I see it.' She then burst out laughing.

'No you silly girl, I was pulling your leg, not a wrestling bout, a Tug-of-War match. We're in training for the Tug-of-War matches at the Gravesend Regatta. Dave's our anchor man.' Eddy L. then looked at his watch, and cried out loud. 'Damn it Dave. Look at the time. We've got to get back to work.'

They gulped down their mugs of tea, and hurriedly walked off back to their jobs. As they walked along the quay they began eating their bread and dripping sandwiches, with salt added.

The Sequel to this Story

Big Dave had been marched before the Hon. Colonel What-What! He had assumed he was going to be congratulated on his wrestling match win, instead all he got for his trouble was a ticking off by the Hon. Colonel for his total lack of 'true British sportsmanship'.

'Damn poor show that *Private*, What-What!' the Colonel told him, 'One thought that at the very least you'd have given that poor chap a fighting chance. After all, the fellow did come here to entertain my soldiers, What-What! The bout only lasted for two minutes. Damn poor show that *Private* er um What-What!' He waved his hands in apparent disgust and shook his head before saying:

'Dismiss that soldier, Sergeant Major (S.M.), What-What!'

''Shun,' the S.M. had barked out. ''bout turn, quick march, left-right, left-right, left-right,' as he was hustled by a bemused S.M. out of the Colonel's office.

When he got outside the Hon. Colonel's office, it was a different story. It seemed the whole battalion was out there waiting to congratulate him on his win. It had started to rain, one of those monsoon downpours. Some of his silly sodden wet comrades, laughing like a pack of hyenas, tried to lift him onto their shoulders, but they only managed to get him shoulder high before dropping him into a deep pool of slimy, black mud.

'Yes!' Eddy L. later explained. 'The stupid fools dropped you right on top of me.'

'Yes! That was a bonus. It was the only part of the sporting events I enjoyed that day,' said Dave laughing loudly. 'It took four of our mates to pull you out of that muddy mire, didn't it Eddy. A bloody good show that was, What-What!'

TALE 2
Striking Freight

Striking freight off road vehicles, railway wagons and box trucks (striking freight means taking off), was the primary function of Port of London Authority *permanent dock labourers*, as they were derogatorily called within the Port of London by its governing body, its management and clerical staff. That was until the introduction of full time employment for all Registered Dock Workers was finally achieved in the latter half of the 1960s and early 1970s. For it was not until after that period of the twentieth century that shipping companies began to operate their own system of receiving and striking export cargoes. That is work operations began to include striking cargo for general shipment, and the filling of containers within the enclosed docks.

Containers, as they are generally referred to, are large steel boxes that range in length from 8 to 40 feet, and are capable of holding from 512 to 2,560 cubic feet of freight. It has to be emphasised here that containers are actually mobile warehouses. That is they are self contained sealed storage capsules, capable of being collected direct from manufacturers, and delivered to the receiving merchants, without its contents having to be manhandled again. (The removal and collection of goods by containers is not a modern invention; railway companies were collecting and delivering goods by boxed rail-truck in the late nineteenth and early twentieth centuries.)

The term *permanent labourer* was, and still is, used to describe Registered Dockers and Stevedores in the employment of the Port of London Authority on a permanent basis. It was a demeaning salutation, and was deliberately meant to be. Presumably because it gave other port authority employees, who were credited with having 'staff status', and the general public through media propaganda, the intended false impression of Registered Dockers and Stevedores as being no more than illiterate beasts of burden. That is the 'so called' labouring classes of society, who are to be looked down on by those people who described themselves as, 'the middle and upper classes'. Now you, the reader, must know the type of persons being referred to. That is the people my erstwhile university educated workmate Terry (a trade unionist and labour party sympathiser) always described as 'the airs and graces parasites, that live off the backs of we wealth producing workers'. They looked down on the labouring classes instead of depicting them as being the highly skilled working men they really were. (The term 'former permanent labourer' is still used to this very day in the obituary columns of the *Port News*, a newspaper published on behalf of the port of London authority, when describing its late former permanent registered dock workers employee status.)

However, it is a fact that many of those people who used this terminology were totally ignorant of the many skills required in dock work operations. In particular those jobs undertaken by Port Authority 'perms', or for that matter dockers and stevedores registered under the Dock Workers Regulation of Employment Acts in general. These were men who were 'picked up' by ship workers in the Dock Labour Compounds to load or discharge vessels of every type from the largest luxury liners and deep sea trading ships, down to the smallest short sea trading vessels. Ships that came from every country on this Earth, in all shapes and sizes, including locally employed river craft. These were barges and lighters used specifically for moving freight

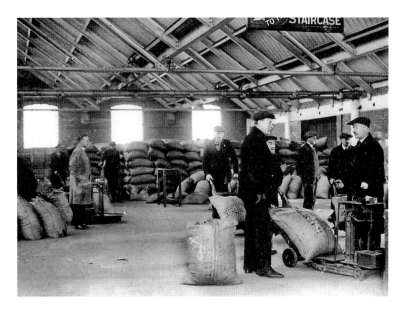

A Port of London Authority import delivery gang, weighing sacks of cargo before it is dispatched to the Importing Merchant, *c.* 1920s.

from dock to dock, or from docks to merchant's wharves. These were riverside quays or wharves that may be located at various sites along the river's banks. Sailing barges were worked too, which carried cargoes to and from destinations around the British coast, or even as far as countries on the European continent.

The reason for this denigrating ploy was no doubt deliberate, because it was meant to convey a message, which intentionally failed to acknowledge dockworkers as being highly skilled technicians in their own right. This attitude, it appears, had the intention to both deny and refuse to acknowledge, or to accept that there had been vast changes in ship design, sizes, and tonnage carrying capacity during the nineteenth and twentieth centuries. Technological advances that required changes to be made in work practices; skills that dockers and stevedores developed for themselves. Such perverse attitudes shunned acceptance of the essential skills required in the utilisation of new developments and inventions. In particular, the skills associated with the mechanical plant and equipment that is required and provided, both on ships and dock quays, to service the fleets of ever changing liners and freight carrying cargo boats that trade the many shipping routes throughout the world. Moreover, for the continuous change in those skills required of Registered Dock Workers, who operated and worked all cargo carrying vessels within the major ports of the British Isles.

In other words, the disrespectful salutation fails to reflect the skills required in dock work generally, and the use of mechanical appliances in particular. However, before continuing with this tale, it has to be emphasised that many mechanical appliances operate on a slower basis than human manpower. Therefore, quite obviously, if freight could be moved faster by manpower than by mechanical means, then the human physical factor would predominate. This has to be explained simply, because all dock work jobs were paid on a piecework tonnage basis, and that was the crux of the altercation that is described below.

Now on becoming a 'perm' in the employ of the Port of London Authority, a docker or stevedore had to perform the following feats and obtain these skills: swim the width of a dock; drive eighty-foot luff Stothard and Pitt quay cranes; drive a variety of other types of quay cranes both electric and hydraulic; and drive various makes of mobile cranes and electric trucks. They also had to be able to drive all forms of other motorised vehicles from tractors to heavy lorries, army vehicles and forklift trucks, and later, after the container revolution, container carriers and heavy lift container cranes.

In addition, 'Perms' often had to work in place of Port Authority clerks as well, when there was a shortage of Port Authority grade five clerical staff, to cover dock work operations. They also had to be physically fit, fit enough that is to push hand propelled wheelbarrows, weighted down with all manner of shapes and sizes of packages for hours on end. In addition, 'Perms' acted as assistants to HM Customs Officers carrying out inspections on consignments of cargo that had to be legally examined; or, cargo that was suspected of containing contraband. In other words 'perms' had to be capable of dealing with any job that had to do with cargo handling dock work that was the contractual responsibility of the Port of London Authority. Finally, all cargo-handling operations where 'perms' were employed were paid at the 'piecework rate' of six pence per ton for each man.

However, there was one job that was not within the remit of 'perms' permitted area of operations. That was the removal of export goods from or onto lorries, or other transport vehicles, by working on the vehicles themselves. This anomaly was due to the Port Authority's refusal to insure the men against industrial injuries that may, and invariably had happened to some of them, while they were striking cargo from road transport vehicles.

That policy was as spurious as it was naïve, simply because the striking gangs were paid on a tonnage piecework basis, and lorry drivers should never have been expected to lift or carry his load onto the cargo bank. Of course, the policy decision was made due to a judgement in the High Court, in a case where it was found that a Port Authority 'perm', who was injured by falling off a lorry, had not been given permission to enter that vehicle either verbally or in writing by the vehicle's driver or the Port Authority's warehouse foreman, and that he was acting outside his contractual duties. His case had been dismissed with costs against the Trade Union that had sought to obtain recompense for his injuries. Injuries, incidentally, that had brought his port registration to an abrupt and painful end, and left the man in question, and his family, destitute.

The consequence of that High Court Judgement, and the lack of any real responsible management policy regarding the striking of freight off road transport vehicles, was the reason that so many Port Authority 'perms' avoided actually working on road transport, but not Big G. He was a 'perm' and a piecework operator. He was not given over to following any practices that reduced his earnings. His often stated view on High Court decision as they referred to work practices was:

'Pox on judges, they don't have to suffer financially from the stupid decisions they make. If we took any notice of some of their decisions, we would have to give up coming to work. We are paid by the deadweight ton as pieceworkers. We do what we have to do, whether it's legal or illegal. Just let's get on with the job.' That is exactly what he did, and woe betide anyone who tried to stand in his way. All the Port Authority warehouse or transit shed foremen loved to have him working for them because they got a greater tonnage turnover without having to worry about the legal consequences if there was an accident.

Any 'perm' that worked with him was expected to follow his lead, and get on with any job they were detailed to carry out by him. The Port Authority warehouse or transit shed foremen and traffic officers closed their eyes to his practices, simply because he was a law unto himself where dock work was concerned. Big G. came to work only to earn money, breaking 'rules or common laws' to reach his objective was neither here nor there to him. He worked ten hours a day, every day. He worked seven days a week, every week. He worked fifty-one weeks a year, every year. He would have worked all fifty-two weeks of the year, but he had to take a compulsory week's holiday. A week off work that he considered was an infringement on his personal liberty.

On the day of this tale, Big G. was in charge of a freight striking gang, unloading heavy cases of machine parts off lorries at the rear of a transit shed in Tilbury docks. He was, as usual, on the back of

a lorry with his docker's hook in his hand, loading hand trucks with packing cases, crates and cartons. Then he had come onto heavy crates; crates that any ordinary human being would have had to call for the use of a mobile crane to move. Not so Big G.

'Get a collies truck and boards,' he ordered.

A hand trucker trudged off, and soon returned with a Collis truck and pallet boards. Big G pulled one of the boards up against a large case, and he and his workmate loaded it onto the board. Big G then pushed the Collis truck under the pallet board, and he began to pump the machine's handle. The Collis truck and pallet board, with the packing case on it, was too heavy for the lorry's decking; it splintered the wooden decking as the legs of the pallet disappeared under the lorry down to its chassis. The driver, who had been folding his freight sheet covers looked up and swore:

'You stupid bloody idiot,' the lorry driver yelled out, 'I'll come up there and punch you on the nose.'

Big G., as quick as a flash, bent down and grabbing the lorry driver by the collar of his coat, lifted him in a straight line up onto the back of the lorry with one hand, put his index finger up to his nose and said, 'There it is. Do you still want to try it?'

The driver stood on the back of his lorry, frozen to the spot in utter surprise, as he gasped in amazement and surprise at the strength of this man.

'No mate!' he replied with a false laugh, 'I was only joking.'

'Then give us a hand to extricate this lot, or we'll leave you to get the rest of the freight off of the lorry on your own.'

The lorry driver acquiesced by helping to roll the crate off the pallet board. This eased a tense situation, as the striking gang prised the legs of the Collis board that had stapled the Collis truck and board to the floor of the lorry, from under the lorries wooden planking, with steel dolly bars. Between them they cleared the debris. Then, as if by magic, sheets of marine plywood appeared, cut to size, and the lorry decking was repaired to a higher standard than it had been before it had arrived in the docks. The lorry driver was delighted. He was also too wise in the ways of the docklands to ask where the plywood had come from.

The moral of this tale is one should never make threats one cannot carry out. More especially to those people one depends on for one's livelihood. The 'freight striking gang' in this instance, did a magnificent job in repairing the damage to the lorry's decking. For they simply covered the whole back of the vehicle's working platform with sheets of inch thick marine plywood. Plywood, incidentally, they had purloined from an undisclosed source. In fact, the driver had to admit the decking was better and stronger when he left the docks, than when he had come into it. More importantly, the damage to the lorry did not need to be reported in the Port Authority shed foreman's Daily Work Diary. That was a bonus in disguise for everyone concerned, Big G. included, although he was heard to utter these infamous last words:

'That driver had better keep his mouth shut about the plywood decking on his lorry, if he's stopped and questioned by the *copper* in the Police Control Box.'

It was a statement that brought not a few threatening grunts from other members of the freight striking gang.

TALE 3
A Pre-Emptive Warning

The first time I saw a Port of London Authority police officer in action was when I had gone to Tilbury docks to meet my mate, who had just arrived back from a sea voyage to Australia. He had been a member of the deck crew on one of the Orient Line's fleet of ships, the RMS *Orion*. He had sent me a message, asking if I would meet him when the ship arrived in Tilbury Docks, to help him bring his sea going kit back to his home, after the ship had paid off (Paid off – the ship's crew were made redundant).

The ship had arrived in the enclosed dock and berthed and my mate had gone through the usual procedures of clearing customs. That is letting customs officers rummage through his personal possessions, then having a prescribed blue chalk mark drawn on those suit cases that held his personal effects, and too the kit-bag that contained his working clothes. After having wasted at least two hours having his kit inspected, and waiting on the customs officers for a clearance note, we were finally free to lug his gear ashore onto a taxi rank at the rear of a transit shed.

Now I have to point out that local taxi drivers had a financial field day when luxury liners arrived back in their Home Port. Of course, it was so arranged that first class passengers always disembarked from a ship before any of the second or third class passengers were allowed to do so. Their travel trunks and suitcases were picked up by dockers acting as porters, taken to a table to be inspected, and cleared by customs officers in a quayside transit shed. That arrangement was made so they could get clear of the docks before second class passengers were allowed to leave the ship. There were also similar arrangements made to separate second class and third class passengers when disembarking. Only after all a liners passengers had been disembarked were the ship's crew, on having been signed off, permitted to lug their personal effects ashore and make their way home – if they had a home to go to – otherwise it was the Flying Angel (The Seamen's Mission) or accommodation in Smokey Joes Café, till they returned to the ship to sign on for her next voyage.

It was at this point then that the real scramble began between taxi drivers for the last of the 'honey pot'. The honey pot being, of course, the greatest number of fares the drivers could squeeze in, by running their taxis between the berthed ship, local railway station, bus terminal, Smokey Joe's Café, or the Tilbury to Gravesend riverside ferry terminal, from the ship's passengers and crew who they were all dependent on for their livelihoods. The taxi drivers, to be fair about their motive, had to make as much money as they possibly could while they had the chance. There was always gaps in the Pacific and Orient, and Orient liner schedules, that often left Tilbury Docks empty of ships for weeks at a time.

My mate managed to get a taxi quite quickly. We piled his kit bag onto a roof rack, and his suitcase into the taxi's boot. Then we were off to the ferry terminal beside the river Thames, on Tilbury Passenger Landing Stage, or so we thought. Now what people who are not familiar with docks do not understand is that they resembled and are similar to 'Stalags'. That is prison camps

similar to German prisoner of war camps of the Second World War, but with guards in the guise of uniformed Port Authority Police. For dock estates are patrolled 24 hours a day, 7 days a week, 365 days each year, both inside and outside docks. These duties are carried out by the Port Authority's own police force, and enclosed dock areas have manned police boxes sited at every dock entrance and exit.

In addition, there are high wooden fences or brick walls. These are boundaries on the dock perimeters, and vary between fifteen and twenty feet in height – they boarder the whole length of the outer perimeter of the docks. It's not impossible to get into or out of such places, but it would be difficult to break in or out with a heavy motor vehicle unless you knew where to avoid the perimeter ditches and other concealed obstacles. There are, therefore, chinks in the security defence Armour surrounding most docks, but that secret may be revealed in another story.

Having got ourselves installed in a taxi, the driver headed for the Tilbury to Gravesend Ferry Terminal round the outer dock perimeter road. Then as we came close to a Port Authority police box, the taxi driver told my mate to, 'put five shillings in your crew paying off book,' together with your 'customs clearance note,' and give it to the 'copper on the gate' when he stops my taxi. 'If you don't,' the driver warned him, 'this copper will turn your gear inside out, and we'll be here till he's gone through every item; your dirty laundry included.'

My mate did as he was told, and when the taxi stopped, he gave the police constable his customs clearance documents, and two half crowns. The constable glanced at the documents, glared at us through the open taxi window, slipped the two half crowns into his uniform pocket, and then said to the taxi driver:

'Get out. Open the taxi boot,' he ordered. As if he was talking to a criminal.

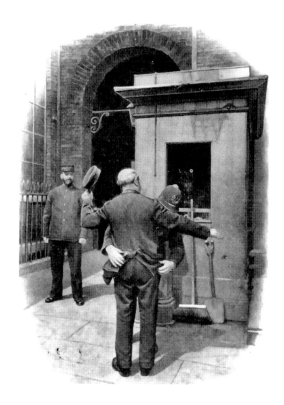

A Port of London police officer carrying out a body search, *c.* 1900s.

The taxi driver obeyed and stood back, while the copper checked the suitcase and the kit bag for customs blue chalk marks. He didn't so much as utter another word to any of us, but when he'd finished his inspection, he just waved his thumb at the taxi driver to get back in his cab, and to be on his way. As we drove off I asked the taxi driver, 'do all dock police blackmail people into giving them bribes?'

'No,' he replied, 'only the odd one or two of them, but we taxi drivers know most of those who do. That character is one of them. He's a really nasty bastard, so steer well away from him. He was a Red Cap (Military Policeman) during the last war. He treats people as though he is still in the army. By the way, be warned and take my advice, if you should ever have to come onto any Port Authority dock premises, for any reason, always remember this. The docks are full of uniformed and plain clothed police officers; paid police informers; police narks recruited from dock thieves; police provocateurs; amateur media reporters selling stories to the press, stories that rarely resemble anything near the truth; political agitators acting as trade unionists; trade unionists working for political parties; and industrial spies in the pay of port employers, Customs, and MI6, the Governments Internal Security Organisation whose primary function is to keep an eye out for political party agitators such as Ted Dickens and Jack Dash, and the other members of the Port of London's Unofficial Liaison Committee. All this and organised criminal gangs too, which operate from inside and outside the docks. You may never get to know any of them, but if you do and you're not one of them, for your own safety keep that information to yourself. It's bloody dangerous if any of the criminal fraternity get to know that you know what they may be up to, or even who they are. I do mean bloody dangerous. Do you get my drift?'

'Yes!' I replied, 'I most certainly do.'

As it turned out, my mate had no British change left to give the taxi driver a tip, so I gave him a half crown. That half crown turned out to be one of the best investments I ever made in my entire life.

So that is the setting for this story. Were we really 'free men' that worked in the Port Transport Industry? What, when we were employed in a prison camp work environment? No, I don't think so! We were wage slaves at the beck and call of paymasters, those descendants of the very same people who were the slave traders, pirates and privateers of by-gone-days, who were now operating in the guise of reputable commercial transportation enterprise operators, revered for their business acumen, and more notably by shareholders who lived off the dividend income from the vast profits that were distributed to them. Profits that were procured at the expense of poorly paid and poorly fed merchant seamen who sailed their ships, and Registered Port Workers whose sweated labour and many skills were required to load and discharge their vessels, who made those dividend incomes possible.

Most Boards of Directors of shipping companies sported a couple of 'titled members', to give them credibility, while other Board Members sat on the by-lines waiting for their turn to be knighted, or to be nominated to take a seat in the 'Upper House'. It was all a bit like the First World War song British soldiers sang:

'One Staff Officer is jumping over another Staff Officer's back, while another Staff Officer is jumping over another Staff Officer's back.' I think this form of ambitious conniving is more generally known as 'one-upmanship'.

After the Second World War had ended, and for many years after, the British Army of the Rhine were supplied with all sorts of equipment by 'short sea trading vessels' that sailed from No. 5 transit shed Tilbury Docks to Hamburg, on a two-ship seven-day 'Charter Party Schedule' on behalf of the Ministry of Defence. I was working with a ship's gang on one of those vessels, acting as the down-hold-foreman at Number 1 Hold. We had been loading heavy field equipment in the lower hold, which

was then over stowed with general wooden cased cargo and cartons. We had replaced the lower hold hatch beams and hatches, and began to floor out the 'tween deck with tank gun barrels to be over stowed with more case work and bales of uniforms and grey woollen socks. This freight was brought to the ship's side, along the quayside, in covered railway wagons direct from army supply depots.

We had a bloke in our gang, a stranger to me, who kept suggesting to the lads they should open certain cases to see what could be thieved. I, having remembered the taxi driver's advice, said nothing. However, he eventually opened a bale that contained grey woollen army socks, he took off his boots and pulled on a new pair of socks, then he replaced his boots on his feet and threw his old socks down between the stringer boards that held the cargo off the inside of the ship's ribs and outer steel plates.

'Now's your chance, mates,' he told my down-holders, 'help your selves.'

Three of the lads followed the stranger's example, and each of them pulled a pair of the grey army socks on their feet, before replacing their boots. But instead of throwing their old socks down between the stringer boards, they threw their old socks in among the cargo. It was at this time the top-hand called down the hold, 'Beer ho'.

This meant the Port Authority's Mobile Tea Van was on the quay with tea, coffee, sandwiches and cakes. The lads clambered up the ship's 'tween deck ladder and made their way ashore to buy mugs of tea and cakes from the Tea Lady. Then, having refuelled themselves, they quickly made their way back to work.

Now every item of cargo has to be checked, marks and numbers taken, and the place it is stowed in the ship's hold recorded, with the actual checking done by an O.S.T. clerk. The O.S.T. clerk to our gang was an old workmate of mine, who had been a docker before he was injured and transferred to the O.S.T. clerical register. He stopped me as I was about to climb down the hatch ladder into the 'tween deck.

'Don C., Jim T., Les M., they've all got army grey woollen socks on they filched from a bale in the 'tween deck at Number 1 Hatch, on that short sea trader berthed at five shed.'

'How do you know that?' I asked him.

'I lost the keys to my Invalid car. They've got my name on them. The pay office sent me a message, telling me to go to the Docks Police Station to collect them. I went over there at 'Beer ho'. When I was at the counter one of your gang sneaked into a side cubicle, and reported to the desk sergeant what I've just told you. Tell your lads to divest themselves of those socks before they go out through the police gate, because the dock police are sure to be waiting for them.'

'Which one of the gang was it that grassed on them?' I asked, although it was obvious to me who the culprit was, and who he was acting as a 'provocateur' for.

'Don't be silly, they're not stupid, it was obviously a paid nark, leave it,' he replied as he walked off down the ship's gangway and onto the quay.

We finished loading the ship, replaced the deck beams, hatches and hatch covers, and collected our 'Attendance Books' from the 'top-hand'. As we made our way ashore I noticed the 'stranger' had disappeared. I said to Don, Jim and Les, 'don't say a word, just follow me.' I walked slowly along the quayside, and entered the only communal toilet at that end of the dock. When we were inside Les asked,

'What's wrong?'

'A nark in the gang has been to the cop-shop, and reported all of you as having filched army grey socks off a ship. Now take them off and give them to me, I'll get rid of them. In the meantime, you must all walk slowly towards the police gate till I catch up with you. We can't leave the socks anywhere around here, the police will obviously have had somebody watching you. When they don't find the

socks on you, when you're searched at the Police Gate, they're sure to put two and two together, and send someone here to look for them.'

They said not one word, took the socks off their feet, and gave them to me. They then pulled their boots back on their feet, and began to make their way slowly towards the Police Gate. I walked back to the ship and dropped down into Number 2 'tween deck through the open deck hatch cover. I shoved the socks down between the stringer boards and climbed back onto the deck. I then made my way ashore once again and caught up with the lads as they came level with the copper at the Police Gate, who was none other than the former Red Cap. He was obviously waiting for them with menace aforethought, standing with legs apart and hands outstretched, by the open door of the Police Box.

'In the box, you lot,' he commanded. We all obeyed like sheep. 'No, not you,' he told me, and he began to shove me towards the door saying, 'get outside.'

'I think I'll stay if you don't mind, constable. These lads have been working with me. If there's a problem, as the down hold foreman, I'll be held responsible.'

'Please yourself,' he snarled. 'Now you lot, roll up your trouser legs.' They obeyed.

He stood there for a moment with a deep frown on his forehead, totally perplexed, looking at three pairs of booted feet without socks.

'Where are the army grey woolly socks?' he blurted out. He was genuinely puzzled, not seeming to comprehend booted feet without socks.

'The only woolly socks we know about, are on the ship we have just left,' I answered.

'I wasn't asking you, I'm asking them?'

'Well it's obvious they haven't got woolly socks, isn't it,' I said. 'I can see they've got no socks at all.'

The Constable stood in silence for what seemed like hours, before he finally picked up a telephone. Then he said into the telephone, 'they've got no socks. No! They've got no socks on their feet at all. No, only their boots. No! No bloody socks,' he shouted down the telephone. 'How do I know what they've done with them, I'll have to let them go. No. I've got no reason to hold them here.' With that the former Red Cap slammed the telephone down, 'Right,' he said, 'you lot can clear off, but don't let me catch any of you with pilfered gear, or you'll all be sorry you made a fool of me.'

The lads filed out of the Police Box like lambs that had realised they had just missed being sent to the slaughterhouse. I, on the other hand, stayed my ground.

'So what are you waiting for,' he growled to me with a sneer on his face, 'clear off.'

'I'm just going,' I told him. 'I've only stopped behind to tell you that if you set out to persecute my workmates, I'll make it my business to inform your superiors about the back-hand bribes you get on the days 'Your Ships Come In'. You know what I'm talking about, those 'tips' you extort from poor bloody sailors on their way home, after being months away at sea. I'm sure the local press would like to know about that too. I'm sure that story would make great headlines, don't you?'

The former Red Cap stood with his mouth a-gasp as I walked out of the Police Box. He was no doubt wondering how I knew about his devious and cunning 'tax free second income'. It really does pay to store information, especially about the most virtuous, loyal, and trustworthy servants within any organisation, simply because one has to ask oneself who those trustworthy servants are actually trustworthy to? As I mentioned earlier, that half crown I gave the taxi driver years before, after my mate had paid that copper five shillings to get out of the dock, was one of the best investments I ever made. Now surely you will agree with that statement. Won't you?

What's Happened to Old Percy?

A ship of the Holt Line that had sailed out of Liverpool, partly loaded, was berthed alongside Tilbury Docks Riverside Deep Water Jetty, waiting to complete her loading with refined white sugar. It had only a thousand tons of white refined sugar to be put aboard the ship, which was packaged in two-hundredweight (100 kilo) hessian sack. The sugar cargo was being exported to Nigeria, through the port of Lagos on the West Coast of Central Africa, a country known to explorers and seamen in the not too distant past as, *The White Man's Grave*. This was more specifically because of the malaria, yellow fever, and other parasitic diseases, carried by blood sucking female mosquitoes, that thrive within the vast areas of tropical swamplands, which cover hundreds of miles of hinterland adjacent to the rivers Niger, Benue, and Cross. These vast river complexes are now used as major water transport facilities for trade in oil exports and general commerce, rather than the tribal cannibalism that was once said to flourish in that part of the African continent.

Thames lighters, some dozen or more of them, had been towed down the Thames from Tate and Lyle's sugar refinery at Silvertown, North Woolwich. They had been brought down the river on the early morning ebb tide, and assembled in the calm water between the inside of the Deep Water Jetty and the river's sea wall, which was also Tilbury Docks boundary line with the river Thames.

Meanwhile, in the Dock Labour Compound, a stevedoring contractor's ship worker was trying his best to entice gangs of dockers to man the sugar boat. There had been no work available for the men for some time, and they had been proving attendance at the Dock Labour Board all of the previous week. It was now Friday, and that meant those men with eight 'proving stamps' on their Attendance Books could not improve on their 'fall-back guarantee' payment, and they would also be missing out on a chance for Sunday work. What's more they would be working for no extra take home wages above the 'full back guarantee', if they volunteered for the job. In other words they would be working for the same amount of money if they were allocated to work on the vessel, as they would receive if they did not work at all that day, for sugar at two shillings and eleven pence per ton, split among twelve men, was among the lowest paid piecework rate jobs in the docks. It was a 'catch-22 situation' for Old Percy (a 'B' man over sixty-five years of age), who knew from long experience which way the 'call on' would go. That is only 'A' men would be sent to work and as it was not his 'dabbing on day', he would at least get a day's pay for turning up for work. So he volunteered for the sugar freight loading job.

'Sod 'em,' was the dockers' general consensus of opinion. 'Let's take our chances with being allocated to that damn sugar loading ship. At least if we miss this one we'll be on the 'free for all' call in the morning, with a reasonable chance of getting a job for Sunday.' (Sunday wage payments were paid outside the eleven turn weekly guarantee.)

When the tannoy loud speaker suddenly boomed out, 'all 'A' books in.' The men knew the lottery for 'pressed gang' jobs was about to begin.

As it so happened, the odds against not coming out of the job lottery were quite good. There was to be three working hatches, Numbers 2, 3 and 4, with thirty-six dockers to work the ship and lighters, and three changeover men on the jetty to remove the sets off the shore side cranes, and hook them onto the riverside cranes. Six crane drivers would be required, two to each hatch; one to operate the shore-side crane, and the other to work the crane servicing the ship. The job of loading the ship was always allotted to the most experienced crane drivers. Three O.S.T. clerks were also required to tally the cargo out of the lighters and into the ship's holds. Company ship's clerks would be dealing with the ship's manifest, loading plan, custom's clearing papers, and piecework tonnages for each loading gang, working out of a mobile office inside the docks perimeter fence. Their calculation on hatch tonnage and deck stowage's was based on the O.S.T. clerk's 'tally' of the cargo. If all went well and there were no stoppages, and the barge hands put fourteen bags in a set instead of the usual twelve bags, it would be possible to complete the loading operation that day.

As the names and identification numbers of the men allotted to the 'sugar boat' came over the tannoy loudspeaker system, the unfortunate men whose names had been called out began to make their way from the Dock Labour Compound to an assembly shed, that was inside the dock perimeter fence, close to the Riverside Jetty's cat-walk. This walkway was the only footway crossing between the river's bank and the Riverside Cargo Jetty. The docks perimeter fence was a high wooden latticed structure, which extended round the whole of the working docks. It ran from Tilbury Riverside Passenger Landing Stage to the town of Grays, Essex. The fence almost followed the Southend, Tilbury Riverside to Fenchurch Street railway line. It then ran back along the riverside from Grays, to join up back at Tilbury Riverside Passenger Landing Stage. The docks perimeter fence was continuously patrolled inside by Port of London Authority police officers (real police officers recognised under the Port of London Authority Act 1908, not simply security guards) twenty-four hours a day throughout the whole year. The Riverside Jetty, however, lay outside the perimeter fence, about half a mile from the Dock Labour Board Compound, and could only be accessed by a wicket gate set into the dock perimeter fence. As each man was allocated to the ship, he made his own way to an assembly shed, close to the wicket gate, where the ship worker was waiting with his lists of names ready to call off each man for his specific job – those down in the ship's holds; those in the lighters; the crane drivers and 'top-hands' to the ship's gangs; and the 'crows', who were assembled waiting to be 'told off' to one of the three loading cargo holds. (Crows were men who stood on the Cargo Jetty's decking, and changed over the sets of cargo coming out of the craft, by placing them onto the ship's servicing crane to be put aboard the ship.)

Now it so happened I was allocated to Number 3 Hatch on the Holt cargo ship, to drive an old Wellman crane to service the ship's gang with cargo. These cranes had been erected on the jetty when it was built in 1928. So they were thirty years old at the time of this story. They had been in continuous use all that time, and were worn out relics of their former selves. Although originally designed to lift two tons, the damn things now struggled to hoist thirty hundredweight. They had hand controls for luffing, slewing and hoisting, but a foot peddle for lowering. They were cranes only to be used by highly experienced drivers, and certainly not by novices. Unfortunately, the shore side crane driver allocated to Number 2 Hatch was a complete novice, and as is the case on public roads, novice drivers are a liability simply because they are erratic and think speed is of the essence. So, as you can see, it was in these circumstances that we of the reluctant 'pressed gangs' were set to work loading sugar from lighters into the ship. All of us keeping our fingers crossed that we could complete our own hatch-loading job that day, so we could be in the Dock Labour Compound the next morning with a chance to get a job for Sunday.

Those dockers who were allocated to work in the lighters as barge-hands began to clamber down the perpendicular jetty ladders onto the lighters' decks. The ship's gangs went aboard the vessel up the gangway. We crane drivers climbed up into our designated crane cabins. Work on the loading ship was about to begin. That would be after the tarpaulins, hatch covers, beams and sister beams had been removed, then the loading operation was started. By which time it was about 9.00 a.m., give or take a few minutes, and except for the occasional few oaths and shouts from the 'change-over' men on the jetty, as they were bustled about by sets of sugar, which the novice crane driver was having some difficulty trying to control, the loading operation was going very well. It was then I heard a shout loud and clear:

'You bloody idiot. If you come down here out of that sodden mechanical contraption, I'll break your f***ing neck,' plus many more not too endearing oaths and threats.

Now it has to be explained that Old Percy was in his late sixties, and he was still doing the work of an 'A' man. What is more, he was still as tough as any man half his age. He had seen service as a regular soldier during the First World War. He had become a docker after being discharged from the army before his service period was up, due to wounds he had received in the Battle of the Somme. Now, Old Percy was obviously 'quite vexed' with his double-banking crane driver at Number 2 Hatch. In fact, to be perfectly honest, he was in a fuming rage. As I slewed the Wellman crane from out of the ship's hold over the quay to pick up yet another set of sugar, I saw him hobbling down the jetty 'cat-walk', waving his fist at the shore side crane driver of Number 2 Hatch.

As the morning work period came to a close we crane drivers came out of our cabins and climbed down onto the jetty. The men working in the lighters hauled themselves up the perpendicular ladders onto the jetty from the lighters that had fallen with the tide. (Usually the men working in lighters would get their crane driver to lift them up onto the jetty, but they weren't prepared to take a chance with the novice.) The ship's gangs came up out of the holds and made their way onto shore. Then all of us made our way along the cargo jetty, down the cat-walk to what was known as the Southern Dock Canteen. Well, it was not a canteen in the true sense of the word. It was a licensed public house that also sold tea, coffee, sandwiches and bread rolls with meat of a sort. What sort of meat nobody ever found out, because there had never been an autopsy carried out on it. The rolls and sandwiches were obviously filled from a secret recipe of the brewer who ran the joint, but of course nobody had explained to the landlord acting on behalf of the brewer just what ingredients the aforementioned sandwiches and rolls contained, or for that matter in what year they were cast into shape, or where the filling was manufactured although it was perfectly obvious it was sometime in the past – the long distant past.

One of the dockers had the temerity to ask the Landlord if he knew when it was that hairy mammoths became extinct, because, as he said:

'I'm well aware scientists say mammoths died out about ten thousand years ago. But if I remember rightly, mammoth corpses have been found in permafrost in Siberia, and if these bloody sandwiches and rolls is anything to go by, I would say the Russians made these sandwiches for export sometime in the last ten years. No! Let's try to be a bit more specific. Let's say twenty years ago to be on the safe side. The brewer must have brought them up as a job lot.' A statement to which the Landlord sheepishly asked:

'Do I take it you want to make a complaint?'

A question to which the docker replied, 'A complaint about the rolls and sandwiches, or a complaint about the complaint the animal this meat came from died of.'

To be honest, in my personal opinion, no one in their right mind would have tried putting a date on

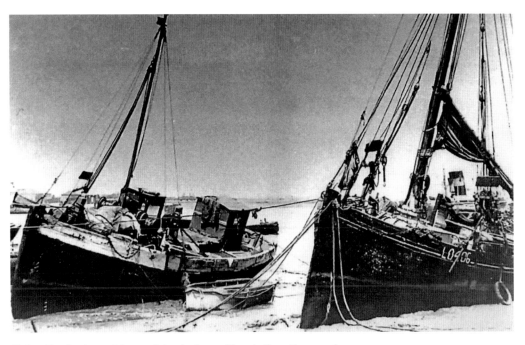

Shrimp Bawley boats. Next to Saint Andrews Church, East Gravesend, *c.* 1930s.

the manufacture of the sandwiches or rolls that were sold to us dockers just after the Second World War. Perhaps, however, one of the BBC's *Going for a Song,* or an *Antiques Roadshow* team member could have made a calculated guess (if they had been inebriated), or even the late Sir Mortimer Wheeler may have tried his luck. However, I doubt whether any of them would have risked their reputations on such a dubious undertaking.

At one o'clock we were all back at work. The loading was going well, and some of the men sensed they could finish loading their hatch and could be in the Dock Labour Compound for the following morning's so called 'free call', with the possibility of a Sunday job in the offing. One of the gang members at Number 2 Hatch had had to come ashore to do the 'change over man's job' on the jetty, as Old Percy hadn't returned to work. The ship's gang down Number 2 Hatch were getting very irate at losing one of their stower's to do the 'change over man's job'.

The moaning of the gang at Number 2 Hatch brought the ship worker out of his office. He came along the jetty and called up to me:

'Where's Old Percy? He's a right one he is! He's not come back from lunch!'

'How should I know where he is?' I called back at him. 'I saw him go off the jetty hours ago. He was swearing at the shore-side crane driver, and limping quite badly. Where did he go when he went off the jetty?'

'I took him to Tilbury hospital in my car,' he replied.

'Hospital?' I said. 'Then, don't you think you should telephone the hospital and find out what's happened to him?'

'I never thought of that', he replied, 'I'll go and do that right away,' and he went striding off to the contractor's office in a huff, while I went on loading sets of sugar with the crane.

I couldn't stop working as the gang had a good chance of completing the loading of Number 3

Hatch by 7.00 p.m., and could therefore be on the 'free call' in the morning, to shape for a Sunday job. They would never have forgiven me if they'd missed being 'paid off' because of a few tons of sugar being left in a lighter.

The ship worker came back along the jetty within half an hour and called up to me, 'It's all right, I know where the old man is, he's still at the hospital. He's only broken his foot, but I'll see he gets paid for the day.'

Well, I thought, he's got a broken foot so that's all right then. It's true the company only had to pay him up till lunch time, so it was benevolent of the ship worker to give the old man a full day's pay. However, as you can see, that's how matter of fact it all was when men were injured. It was one of those unfortunate occurrences that happened far too regularly, to be held in anything other than contempt in its importance – it was just another accident – hard luck.

I called into see Old Percy on my way home from work that evening. He had been discharged from Tilbury hospital at about five o'clock with his foot in plaster of Paris, and had been taken to Tilbury Ferry Passenger Terminal to catch a ferryboat to Gravesend town pier by NHS ambulance. On reaching Gravesend's ferry landing stage he'd had to get two fellow passengers to help him off the ferryboat and then had to get a taxicab to take him home.

He lived on his own, but one of his six daughters came each day to clean and look after his bungalow for him. She would look after him too, till he could get back to work. In the meantime, he was sitting in his chair with his leg up in the air, looking like a beetroot faced retired army colonel, who was suffering from a severe bout of gout due to an over indulgence of Madeira wine, who was laying down in his wheel chair on Brighton beach.

'Are you all right?' I tentatively asked him, knowing from experience he had a very short fused temper.

'All right! What do you think I'm sitting here like this for? Do you think I'm a bloody 'wall flower' at a dance waiting for some bloke to come and ask me to do a quick step or a waltz. If I lay my hands on that f***ing crane driver, I won't only break his sodden legs, I'll break his bloody neck too. The stupid, silly sod, he couldn't take the swing out of the sets of sugar, so he just dropped them down on the jetty. I'm not so sure he wasn't trying to kill me. Every set he brought up out of the lighter, he either tried to drop it on me, or sweep me off the jetty. He was getting more swing out of the jib of that crane, than a doped up conductor could get out of his musicians with his baton at a jazz concert.'

However, Old Percy cheered up no end when I told him,

'Don't worry about getting back to work. I'll have a word with Dan (D. J. Foley the Dock Labour Board's Welfare Officer). He'll advise me what legal action you'll need to take to get compensated for that dock injury. The Dock Labour Board manager should never have sent a novice crane driver on a job like that. Those jetty cranes are difficult enough for the most experienced drivers to control. You've got a sure case for a compensation claim. I'll bet you before Dan's finished with a common law claim on your behalf, you'll be the only bloke on that job who will have made it pay. You may even get enough money out of your claim to treat yourself to a Mediterranean Sea Cruise.'

And so he damn well did too, and I never heard the last of it.

TALE 5
A Regrettable Incident

It was raining, a really heavy steady drenching downpour. It had been raining for hours. God in his heaven, it appeared, had pulled his bath plug to create a veritable tumbling main. The sky above our heads was dark grey and black in colour, and with the wind scudding rain clouds from the west down the Thames river valley towards the estuary as they made their way towards the North Sea, it was obviously going to continue raining for the rest of that day.

I was the crane driver working with a ship's gang that had begun discharging a cargo of groundnuts from West Africa, two days before. However, due to the inclement weather we had already lost one whole day's piecework earnings on the previous day, and everyone in the gang was in a pensive mood, all of them worrying about their next week's pay packet. Unfortunately there is nothing anyone can possibly do about controlling the weather, that's in the lap of the Gods, but there are people who have the power to control work practices, or try to for the wrong reasons, and that's what this tale is about.

Groundnuts are one of those commodities that should never be discharged in wet weather, and certainly not during heavy rain storms, quite simply because once they get damp a fungi quickly turns to mildew, and causes the whole cargo to be condemned for human consumption. So Big Dave (hence forth to be known as Dave) who was in charge of the gang at Number 3 Cargo Hatch, had quite rightly given the order for the gang to hoist the dolly-brook over the ship's hold. (Dolly-brooks are large canvas tents that may be drawn over the whole of a ship's cargo hold to keep out rain or snow. They are also often used to cover a ship's hold when gangs finish work at night, this may be in order to save them from having to replace the ship's beams and hatches, which is a time consuming job and wastes piecework earning time.)

A dolly-brook, when it is in use on board a ship, is held in place by a ship's union purchase, which is drawn up to a derrick's head by a ship's winch. Rope tails are attached all round the base of a dolly-brook, and these are secured by tying them all round the outside of a hatch combing. This forms a huge tent that covers the whole of a ship's cargo hatch and protects the cargo from inclement weather.

The ship's discharging gang at Number 3 Hatch were sitting on bags of groundnuts, in semi-darkness, under a cluster lamp in the upper 'tween deck, talking about trivial things in general and waiting for the rain to stop. When quite suddenly Harry G., the ship's after foreman, came down the hatchway ladder cursing.

Harry G. had obviously been having a few 'duty free' drinks with the ship's mate, who had no doubt egged him on to get the ship's gangs back to work. This was, of course, because once the groundnuts had been discharged off the ship, the ship's owners were no longer responsible for the consignment. It was, therefore, in the shipping company's interest to get the groundnut cargo off the ship into lighters, so the ship could be made ready to reload with export cargo, and get back to sea. This was simply because a ship in port isn't earning money, in fact, with demurrage and labour costs it's a financial liability. So no doubt the ship's mate must have thought Harry G. (who was an ex-prizefighter), the 'after foreman' to

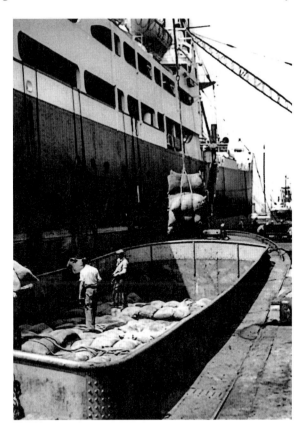

Discharging groundnuts over-side between
ship and quay, *c.* 1950s.

the ship, was just the man to stimulate the gang into action, and get them back to work discharging the
groundnuts, especially as he had bolstered him up with 'duty free' drink. However, Harry should never
have tried to get work started with a threatening attitude, not in the docklands that is (ex-prizefighter
that he was), as he was soon to find out to his detriment, when he climbed down into the ship's 'tween
deck and verbally burst out with, 'What do you lot think you're doing, lazing about down here, sunning
your selves under that light cluster. This isn't a damn Warner holiday camp, you know! Now take that
bloody dolly-brook down, and get back to work,' he ordered with a distinctive slur in his voice.

Now this frenzy came as a shock to the gang. Harry G. was usually a very amicable bloke, when
he was free of cheap booze that is. He was a big man, about six foot tall, with a broad chest and wide
shoulders. He had fair hair that was showing signs of greying round the temples, and thick eyebrows
that partially covered a number of small scars round his eye sockets. He had bright blue eyes, which
seemed to sparkle above a flattened nose – a sure sign he had been a professional pugilist, and knew
how to handle himself in a fight. Harry G. had weighed in at sixteen stones when he had been a
prizefighter on the American boxing circuit, after the Second World War. However, it was a well-
known fact, at least among the docking fraternity, that if you couldn't make the upper grade quickly
out there you're prize-fighting career was soon over. There was also another fact that added to his
woes. Harry G. showed obvious signs of being slightly punch-drunk.

Harry G. had come back home to England, back to the London's East End docklands he'd known
so well, after he had realised his fighting days in America were finished. He had returned to a bombed
out docklands, not able at first to recognise the place he had grown up. That was before he had been
called up for wartime service with the Royal Navy. During his naval service he had obtained the rank

of Chief Petty Officer Physical Training Instructor (PTI). It was a position he thought would enhance his standing in the local dockland community, but in that he was sorely disappointed.

On his return home, Harry had then got his 'dock workers brief' through the good offices of a shipping company, and followed his father and brothers into the docking industry as a Registered Dock Worker. It had been a bitter pill for him to swallow, after he had thought he had escaped his inheritance of wage slavery in the docks. So it had been a God sent opportunity to him when he had been promoted to 'ship's after foreman' some three months before this most regrettable incident occurred. His promotion, however, wasn't because he had much idea of how to manage ship's loading or discharging gangs. It was more because it was assumed by the shipping company's manager (quite wrongly), that Harry's previous experiences as a prizefighter might engender some much needed respect for his own minimal and very much maligned authority. Such a stupid idea mark you in an industry filled to the brim with ex-service men, each one of whom had been trained up to the hilt to fight, kill, or be killed by physical training and unarmed combat instructors – such as Harry G. himself.

Now Dave was the gentlest of giants, he stood 6 foot 6 inches tall, and weighed 25 stones, all of which was solid bone and muscle. Dave had never been known to take unfair advantage of his size, strength and bulk. Except, that is, when he became the Heavy Weight Wrestling Champion of India during his time in the army, and that he would laughingly tell you was only to prevent himself from suffering a 'death worse than fate'.

Dave had attended a secondary boys' school from the ages of eleven to fourteen, whose major sport was boxing. The school had trained most schoolboy champions for its county since it had opened in the 1920s. Dave had been one of them, winning County Schoolboy Champion titles in 1928 and 1930. He had therefore learnt ring craft from an early age, and like all trained fighting personnel, his actions and reactions were instinctive when any form of physical danger was evident.

'Didn't you lot hear what I've just told you. Get this bloody show back on the road.'

Dave burst out laughing and stood up. 'Harry thinks he's still roaming round America with the prizefighters.'

That was as far as Dave managed to get, before Harry G. let fly at him with a vicious right hook.

Dave's reaction was automatic, as his schoolboy ring-craft training instantly took over. He swung his huge body round to his left towards the incoming fist, and swayed backwards so as to reduce the power of the blow, while at the same time he swung his huge arms outwards to save himself from falling. Unfortunately Dave's forearm struck Harry G. fully across his chest. The blow sent the after foreman spinning some 5 yards along the 'tween deck, where he landed with an almighty thud against the ship's steel bulkhead. Dave quickly regained his composure, and rushed to Harry's side.

'Jesus Christ Harry, I'm sorry about that,' he blurted out.

Harry was lying on his back, holding his chest where Dave's huge arm had struck him, and he was finding it hard to breathe, but he finally managed to gasp out.

'It wasn't your fault, Dave. I've had a few too many drinks with the ship's mate. It was a reflex action, I should have known better,' he forced himself to grin and continued, 'you're bigger than me, we'd better look on it as being a most regrettable incident.'

Harry struggled to pull himself up onto his feet. Quite possibly he'd had to do the same exercise, after having been knocked down in boxing rings. But he steadfastly refused to accept any help from the gang, while still holding his chest. When he had got up, he made his way slowly to the deck hatch ladder, and even more slowly climbed out onto the ship's deck, where he collapsed. A port authority police ambulance was sent for, which whisked Harry off to hospital. That was the last time we saw him.

'What was you going to say when Harry tried to hit you?' one of the gang asked Dave.

'Circus. That's what I was going to say. He thinks he's still roaming round America with a prizefighter's circus,' Dave repeated.

The Sequel to this Tale

Six weeks after the incident on board the groundnut discharging ship, Harry died. It was an event that was recorded as being an unaccountable shipboard accident. Harry's brother brought Dave a note that simply stated:

> Dave,
> Just a note to let you know I'm sorry about the event that led up to the accident. As you know, I'd had a few too many *duty frees* (drinks), and let my hands rule my head. That's no excuse for my action. I hope you won't ever harbour any ill feeling towards me,
>
> <div align="right">Harry.</div>

Dave looked down at Harry's brother, but he said not one word. He held out his hand and the two men shook hands. There was no animosity. That's the way things most often were in the docklands.

Harry's brother said, 'Harry told me what happened, Dave. He must have been damn crazy to come at you like he did. But as he said, it's best looked on as a most regrettable accident, and left like that. What's done is done. Mum's the word.' Then he said, 'destroy that note.'

As he turned to walk away across the ship's deck, and began to disappear down the gangway, Dave ripped the note to shreds before throwing the pieces down onto the dock water, where he watched them as they drifted slowly away. That most regrettable incident has never been mentioned again since then. Well. Not until now that is.

TALE 6
Tar Brush and his Insubordination to a Senior Docker

Ron (Tar Brush) who henceforth I shall refer to (most of the time) simply as Ron, was a well known character in the docklands because, with all due respect to him, he was a frustrated oddball of a man, best known to most dockers by the sobriquet Tar Brush, which was sometimes reduced, when referring to him, by simply calling him Brush. It was, to say the least, a verbal technique (by calling him Brush, that is) used by soft speaking men, who had learnt in the days of their military service to keep their mouths shut, their thoughts to themselves, and to say as little as possible. What's more it saved the use of a word, and most dockers of the older generation used words as if they were more precious than water in a desert. To them, 50 per cent of a short sentence was well worth saving. (For the record Ron's second sobriquet was, that bloody bomb happy lunatic, the reason for which you will come to learn about later in this tale.)

Tar Brush's Christian name was Ron. The name Tar Brush derived from Ron's thick black moustache, a monstrous hairy mass that clung to his upper lip from which the hairs stood out like the spines of a sea urchin clinging a rock. Ron was an oddball in so far as he was not only mentally frustrated, but he was erratic too, in the sense that he was always on edge, and one could never predict what he would do next. Ron had, in fact, a condition known colloquially among ex-service men, who had been affected by too much front line action in the various wars they had been involved in, as being 'bomb happy'. In Ron's case this was an inverted truth, as he had served during the Second World War in bomber command.

Ron was a short, stocky man, with black hair going grey round his temples and ears. He had entered the port transport industry soon after his demobilisation from the Royal Air Force (RAF) in 1945, after having spent the whole of the war as a Sergeant Air Gunner on various types of warplanes. He had ended his war as rear gunner in a Lancaster bomber, but during the war he had flown on over fifty operational flights in five years and survived – physically that is. But to be honest, Ron was a nervous wreck, with a tendency to fly off the handle at anything he saw as giving him the slightest provocation. Those dockers that regularly worked with him knew of his unfortunate 'bomb happy' affliction, a nervous mental reaction that caused him to 'let fly' at any perpetrator of his frustration. They just walked away from him when he 'flipped his lid', and left him till he cooled down.

This was not always an option, as what follows is testament to his generally accepted, understandable, irrational, psychopathic mental condition, and his antisocial behaviour. A mental condition that (with a demobilisation suit of clothes and a thirty pound gratuity awarded to him by a grateful government, when he left the RAF) was his only reward for fighting for his King and Country. Ron was not alone in the condition from which he suffered. There were quite a large number of men in the same situation in the docklands. Human jetsam discarded by governments after numerous wars and peacetime battles that took place in faraway places, with strange sounding names, in countries such as India, China, Libya and Egypt. Also Burmese mountain frontier villages; towns and villages in Persia; the Western Desert of North Africa, and numerous other war zones throughout the world. Ron was, in fact, far from being alone in his state induced psychopathic mental morass.

However, Ron, it has to be stressed, nursed an ambition to be promoted to ship worker, that is a person who is employed by shipping lines or stevedoring contracting companies to be responsible for manning vessels to load or discharge cargoes (acting under a ship loading or discharging officer). However, despite Ron being a crane driver, which under most shipping line or stevedoring contracting companies' normal promotional practices would have put him at the top of any companies list for promotion to at least an A.F. (Assistant Foreman), he could not meet the criteria of dependability necessary for such a responsible position. Ron, therefore, had to content himself with being a crane driver or top-hand to ship's gangs. (A top-hand is the person who gives directions to crane drivers, or winch drivers, when ships are working cargoes.)

Ron also had another nickname, 'Bombs Away.' It was a title bestowed on him due to his habit, when driving a crane, of letting sets of cargo drop down at full speed when given the signal to lower. The sets would land with loud resounding thuds, usually to cheers from the gang with such remarks as, 'Dead on target Brush,' or 'one more bombing run like that, and you'll kill the bloody lot of us. You stupid, bomb happy sot,' or words to that effect.

Sometimes more than a few blasphemous words would be directed at Tar Brush (a Roman Catholic), and they would generally be taken as a personal slight (which they were meant to be), and be followed by more bombing raids aimed at all and sundry within a 'ninety foot radius' of an 'eighty foot jibed quay crane'. That excitement would continue until The Brush cooled down, which could be an indeterminate time. So, the ship's gangs he worked with had a vested interest, for their own peace of mind and safety, to give Tar Brush the top-hand's job, as opposed to that of crane driver, when they worked on ships. I don't think there was anything malicious in their intensions. It was simply a case of being better safe than sorry.

Now it so happened that I was in the Dock Labour Board Compound on the 'Free Call', when Charlie C., my dock working mentor ship worker for the stevedoring company that was contracted to discharge a ship of an American State Line shipping company's transatlantic service, called me over to the 'Calling on Stand'. I knew the ship he was working had begun discharging United States army stores from America. For example, equipment manufactured specifically for direct distribution to American Armed Forces stationed throughout the United Kingdom, among which cargoes was included specially prepared food, such as cream cakes and ice creams that had been stowed in freezer cupboards. The information on her time of arrival had been listed in *Lloyds Shipping Gazette*, and gangs had been picked up and put to work on the previous day.

However, Charlie C. required an A.F. (Assistant Foreman) and he had arranged with a quay delivery foreman to pick me up as a crane driver, so that I should be in the Dock Labour Compound when he wanted to call on my services, and had come into the compound this morning especially to 'Call Me On'.

'I've got a job for you,' he said, 'I'm picking you up as a "needle-man" for the state boat (a "needle-man's" job aboard a ship was to sew up damaged sacks before they were sent ashore or onto a barge). She's berthed at Number 1 shed, but that's not the job I want you to do. I'll tell you what that is when we get aboard the ship. OK.'

Having given me my orders, Charlie walked out of the Dock Labour Compound, and I followed him shortly after. When I arrived on board the ship, Charlie was waiting for me at the top of the ship's gangway, and when I joined him we began to walk fore'ard of the ship towards her bow.

'Right,' said Charlie, 'I've got an appointment with my solicitor, and will be away from the ship for a couple of hours. I've spoken to the Governor, Mr Edwards. So he knows all about it. Now this is what I want you to do. When Tar Brush's gang has completed the discharging operation in the lower hold at

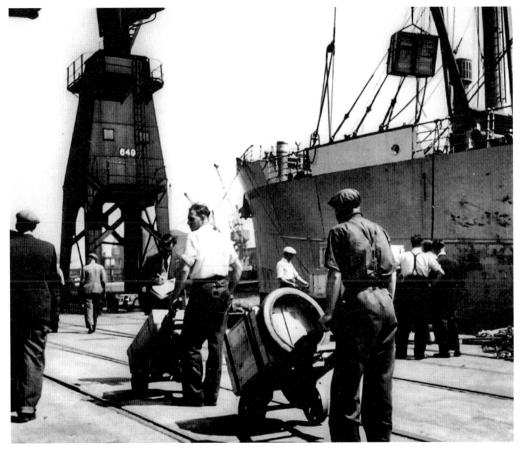

A Port of London quay gang wheel barrowing general cargo to the 'pitch' to be made ready for shipment, *c.* 1950s.

Number 5 Hatch, tell him to bring the stacker truck up on deck, and cover up the lower 'tween deck. He can then set his gang to opening up the freezer cupboards, and discharge the ice cream and cream cakes. There are American army lorries on the quay waiting for us to discharge the perishable stores. So tell Tar Brush to get a move on, and to lay off the cream cakes and doughnuts. The gang at Number 2 Hatch has not finished discharging the lower hold yet. John M. (a down holder) has been struck by a set of cargo. A Port Authority ambulance should be on its way by now to take him to hospital. He's been laid up close against a bulkhead at the fore end of the hatch, so the gang can go on working. I'll be back as soon as I can. By the way, you're the A.F (Assistant Foreman) on this ship. I've had you booked in as pro-rata to the top gangs piecework earnings. OK.' With those final words Charlie went ashore, and left me standing on deck at Number 2 Hatch, waiting for the 'blood wagon' (ambulance) to arrive to cart John M. off to hospital. (Not an uncommon event in the Port Transport Industry those days.)

The hatch combings on United States' ship were high above the deck, about 6 feet above deck level. Two steel plates had been welded to the steel hatch frame to act as steps for the 'top-hand' to stand on, so he could peer down into the ship's hold. Tar Brush was standing on the top step holding on to the hatch rail with his left hand, and calling along the deck for Charlie. I walked aft from Number 2

hold hatchway, and had just begun to say, 'Charlie has told me to tell you,' when I received a thump, a heavy blow to my jaw. It came from Brush's right fist, and as he struck me he began bellowing like a mad bull,

'You're not telling me what to do,' he screamed out. 'I've got more experience than you. I'll teach you, you F***in' bastard, etc.' He then jumped down from the hatch step onto the deck, and tried striking me again with a left hook. I rolled my head back to avoid the blow, grabbed him by the crutch and the upper part of his body, and struck him against the hatch combing. He gave a loud gasp as the wind was knocked out of him. I just let him fall onto the ship's deck, where he laid moaning about his back, and gasped for breath. I walked away from the scene to put some distance between myself and 'The Brush', knowing full well how volatile he could be when he flipped his lid, but it was at this precise moment a Port Authority police ambulance crew came up the gangway, carrying a stretcher. They saw 'The Brush' laying on the deck, holding his back, and moaning. They didn't ask any questions, they pulled opened the stretcher they were carrying, rolled 'The Brush' onto it, and carted him down the gangway off the ship. He was then shoved into the back of the ambulance. It left me standing open mouthed and dumbfounded. It had all happened so quickly. I looked up at the crane driver who had had a bird's eye view of all that had transpired. He raised his hands palms up, shrugged his shoulders and laughed. 'That was a bit quick, wasn't it' he said.

'The damn fools!' I replied, 'they were meant to come and get John M. out of the lower hold at Number 2 Hatch. He's been lying injured in the lower hold for the past half hour, waiting for them to come and take him off to hospital. Charlie will blow a fuse when he gets back on the ship.' I then dashed off the ship myself and went to the Port Authority's office, where I asked the office clerk to get the ambulance to come back to pick up John M. I then went back on the ship, where I took over the top-hand job now Tar Brush was absent. (Those days the job was more important than the man.) I had the ship's gang removed the stacker truck from the lower hold, covered up the 'tween deck, and open up the freezer cupboards to begin discharging the ice cream and doughnuts onto cargo boards. It was then that Charlie returned on board the ship, closely followed by the Governor, Mr Edwards.

'You've had a bit of trouble, I hear?' said Charlie.

'No problems really, Charlie,' I replied, 'except 'The Brush' had one of his magic moments, and flipped his lid.'

'And you don't call that a problem,' retorted the Governor, 'with the 'hatchway man' taken off to hospital. You don't say that's a problem?'

'No', I replied. 'We haven't missed him. The job's has been going very well. We've more than half emptied the lower 'tween deck cupboards, and the quay gang have almost finished loading the American army lorry convoy on the quayside.'

'That may well be the case,' said the Governor. 'But why did you strike Ron B.?'

'Oh that,' I replied, 'was for insubordination, and for striking a Senior Docker, Governor,'

Mr Edwards burst out laughing. He was laughing when he left the ship, and I was told he was still laughing when he returned to his office. The last thing he was heard to say as he disappeared behind his office door was, 'Insubordination to a Senior Docker, I like that. I've never heard that one before, never. Ha! Ha! Ha!'

Post Script

Tar Brush did not return to the ship. In fact he never went up in a crane or worked on a ship again. The Governor gave him a shore job as a quay gang gearer, supplying them with equipment from the central stores. He was allocated an electric low-loader buggy with a trailer, on which he could often be seen zigzagging along the dock roads, or along the quays. It was as though he was imagining he was piloting a Lancaster bomber, instead of being in a rear gunner's turret, in those fearful days and nights during the Second World War he had spent on bombing raids over enemy territory. In fact, he may not have been a frustrated crane driver hankering after a ship worker's position at all. Perhaps his real ambition was to have been a bomber pilot, so he could have seen where he was going and not always looking out on where he had been.

In case the reader should be concerned as to what happened to John M. It must be explained that when the ambulance crew arrived at the hospital Tar Brush had recovered both his wits and his breath. He told the Port Authority police ambulance crew that had picked him up on the ship that he didn't need to see a doctor. He had then asked how they had come to the ship so fast, when what had happened to him had only just occured. They quickly realised their mistake and returned to the ship. John M. was taken ashore on a specially made stretcher by crane and whisked off to hospital, where X-rays showed he had fractured several vertebras.

Sometime later, Tar Brush visited John M. in hospital to apologise for causing him to have to wait for the Port Authority ambulance to return to the ship to pick him up. 'I could have been in here with you, John!' Tar Brush said without enthusiasm.

John M. replied, 'This is a General Hospital Brush, it's not a Lunatic Asylum.'

'The Brush' had flipped his lid, but before he could cause any problems, he was gently but firmly ejected from the ward and the hospital. When he was out of the hospital grounds, sitting beside a burley male nurse who had been sent to keep an eye on him till he'd cooled off, he suddenly burst out laughing and was heard mumbling to himself, 'A General Hospital, not a Lunatic Asylum, that's a good one. I wonder who John was referring to?'

Jim (Soapy) and the Orange Incident

Jim (I detested his nickname of Soapy) was a human enigma with a social stigma. He was, for some reason unbeknown to me or anyone else that I knew in the docklands for that matter, totally disliked by almost everyone that knew him. No one I knew had any idea about Jim's past, if there was anything at all to be known, as Jim kept himself mainly to himself as much as it was possible in an industry which, by its very nature, was more closely knitted together than Harris Tweed cloth is woven.

Jim had a somewhat swarthy complexion, with black wavy hair, brown eyes, and dark oily olive coloured skin (he looked every bit like a Greek or an Italian). He was about 5 foot 8 inches tall, sturdily built and he had one specific feature that stood out, his head tilted slightly towards his right shoulder. He always wore a neckband that partially hid a jagged scar at the base of the right side of his neck, the result most dockers thought was caused during a knife fight in some back alley brawl when he was serving in the Royal Navy during the Second World War. Jim would never enlighten anyone though, as to how he got what he described as, 'my wartime memorabilia'.

Jim had emigrated from the East End of London to New Zealand in the mid-1930s, but he had returned home just before the Second World War began, to visit his ailing mother. He had joined the Royal Naval Volunteer Reserve (RNVR) before emigrating, and was called up by the Royal Navy before he could return to New Zealand. During the Second World War he had seen action while on Russian convoy duties to Archangel and Murmansk, on North Atlantic convoy duties, and in the South Atlantic against German surface raiders that roved about there to sink Allied merchant ships. He had been with a Royal Navy landing party at Omaha (one of the two American invasion landing beaches on the Cherbourg peninsula, during the invasion of Normandy on 6 June 1944 during the D-Day landings). However, as was the way with men who had really seen a war at the receiving end, Jim rarely ever mentioned the war, or the 'small part' he had played in it.

It may have been because of his dark oily skin that Jim was known as Soapy. For, as I have already indicated, Jim was disliked by all and sundry, with my being the one exception to the rule. He was one of the two 'pitch hands' to the ship's gang we worked with, and he always pulled his weight where work was concerned, but one of his obvious faults was that he generally had a wide grin on his round, wrinkled, man in the moon face. An apparent affliction that did not go down too well with our workmates when things got a bit out of hand and tempers frayed. However, it has to be said, Jim never lost his temper, or got involved in fisticuffs. If things began to get heated, he just turned and walked away. I personally found this hard to understand because it stood out a mile that he could more than look after himself if needs be. It was obvious too that the scar on his neck hadn't got there while he had been playing tiddlywinks. But, with all his faults, if he had any, he was loyal to his workmates. He would never let them down, even though they always appeared to be bloody-minded towards him. This then, is the background to my story. It's all about loyalty.

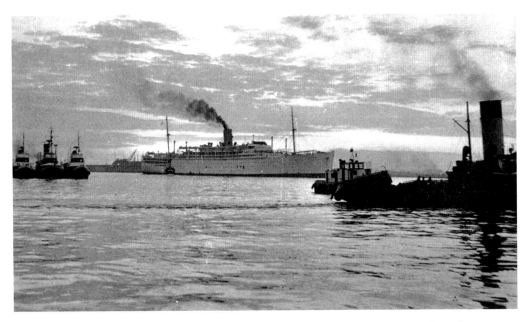

A Pacific and Orient liner leaving Tilbury Riverside Passenger Landing Stage *en route* to Australia, *c.* 1950s.

We had finished loading the P&O liner the RMS *Strathnaver* in Tilbury Docks, and she had been floated out of her berth into the Thames to be berthed beside Tilbury Riverside Landing Stage, where she was due to pick up a few First Class passengers, and British emigrants to Australia, who would be sailing on the ten-pound Australian Government subsidised passage. Also the ship was to take on several hundred children; the first consignment of some 100,000, who had been taken from various Children's Homes throughout Britain, were being exiled without their consent or even a trial. Unlike the criminals of the eighteenth and nineteenth centuries who were at least tried before being deported. It was rumoured they were the illegitimate off-spring of British women and foreign servicemen that had been placed in orphanages by their mothers before their husbands returned home from overseas service. They were being sent to what was termed to be 'their new homes with a brighter future' in Australia.

(The policy of encouraging British adult migrations, and the forced deportation of British children from orphanages was being exploited by British governments, while at the same time immigrants from overseas, with their families, were being encouraged to come and settle in Britain. Why?)

The same gangs that had loaded cargo into the ship while she was berthed in the docks had been 'picked up' the following day in the Dock Labour Compound, and detailed to the same ship now that she was berthed at Tilbury Landing Stage. They were there to load passenger's cabin and hold baggage, and some passenger's motor vehicles that were being shipped as cargo by some of the wealthier passengers, for their personal use when the ship reached its destination. (In the years that followed the Second World War large numbers of wealthy people took to wintering in Australia. Some of them took their personal transport with them.)

All the ship's loading gangs were standing by at 8.00 a.m., although the first train bringing emigrant passengers was not due till 9.00 a.m. The hired cars, taxies and private cars bringing First Class passengers were not expected until after 10.00 a.m. The ship was due to sail at 2.00 p.m. In the

The John Ellerman Liner *City of Durham* off Northfleet Hope in the River Thames, *c.* 1960.

meantime, the 'top-hands' and winch drivers were adjusting the ship's derricks and guys, and the 'lazy guys' that had been rigged by the ship's lascar deck crew onto deck and deck rail cleats. They set about scrounging oil from the engine room to lubricate the wire runners on the winch drums; they greased the union purchase hooks and swivels, to be sure they would revolve so that the cargo nets, which were used to bring the baggage from the landing stage up onto the ship's deck, did not spin in circles when it came aboard the ship.

While these operations were going on the 'pitch hands' to Number 1 Hatch walked along the quay from the bow to the stern, to get aboard the ship. Then because the gang would be working on the open deck they had to climb up to the top deck, and walk through the First Class passenger saloon to get out onto the deck at Number 1 Hatch, where the First Class passengers baggage would be landed once winched aboard the ship, and where the other members of the ship's gang were already assembled eating their sandwiches and drinking tea from large white Port of London Authority mugs, which the 'tea boy' had borrowed from Mobile Tea Vans over a long period, sometime in the past.

Now, as I have already pointed out, Jim was always amiable and smiling. As he was walking through the passenger saloon he saw the stewards setting the tables for a late breakfast. They were putting out bowls of fruit, so he called to one of them to throw him an orange. A steward did, and just as Jim caught it, a hand shot out from behind one of the columns that decorated the First Class passenger's saloon, grasping him firmly by the scuff of the neck, after which he was quickly hustled out of the dining saloon into a side cabin.

'Stealing fruit off the ship are you?' rasped a Port Authority detective.

'No I'm not,' said Jim. 'A steward has just given it to me.'

'That orange belongs to the P&O shipping company. By accepting it you are a receiver, and under the law, a receiver is classified as being worse than a thief. Now I'll tell you what I'm prepared to do, I won't bring a charge against you if you let me know when you see any of your mates pilfering cargo. Just telephone me on this number, or at the dock police station. Here's the numbers.'

'Keep them,' Jim replied. 'Now I'll tell you what you can do. Charge me if you're going to. I have to work with those blokes out there. If they found out I was a grass, how long do you think I'd last? You get on and nick me.'

'Right, I see,' rasped the detective, 'perhaps not today then! But you can be sure I'll have you inside one day.'

'I'm sure you will do your very best, mate,' replied Jim, 'but if I tell the lads out there what you've just said to me, this ship won't be sailing today. In fact, if I tell our crane driver what you've just said, he'll tell a man he knows who will make it known to your governor what you're up to, and don't kid yourself he won't.'

'Give me that orange and clear off,' was the detective's curt reply, 'before I change my mind.'

Jim did tell the crane driver about that incident, and the crane driver told the man he knew who would inform the detective's governor what he was up to. The detective was called in before his governor, due to that intelligence. The detective told his governor he had recruited several men as narks, and had obtained a number of convictions. He was instantly promoted to detective sergeant, for his effort in setting up a system of 'informers'. So don't ever let anyone ever tell you that docks policing was not run on the lines of a mini-police state within those high perimeter walls and latticed wooden fences, because as this tale shows, it was.

As an After Thought

It was rumoured that the detective sergeant who tried to convert Jim into becoming one of his 'narks' claimed expense payments for his informers (that he pocketed) when he obtained a conviction in the local police court. Well, it was just a rumour after all – wasn't it?

TALE 8

The Greatest Luddite in History. Why?

Unless you have seen and heard an ocean going conventional overseas merchant trading ship, or a short sea trading vessel being loaded or discharged, you can have no idea of the skills required by the men working such ships, nor of the dangers they place themselves in, or are put in. Nor can you imagine the noise that such work operations generate. Noisy, commotional rackets, that appeared to be trying to invoke Dante's *Divine Comedy*; that is damn purgatory without the chance of entry to heaven. Not that that bothered us dockers, because having had to listen to our C. of E. vicars or Holy R.C. Fathers during our infant and adolescent years, we all knew we were on the road to damnation, and didn't stand a chance of going to heaven anyway. What's more, if they were going to be in heaven, it gave us more fear than pleasure to think we may have to join that sanctimonious lot of sots for a round of ear bashing said to be in the name of God that would go on and on eternally.

The noise coming from steam winches, that hiss and spit like feral cats; the cracking of union purchases, as the weight of the cargo snaps them together; the whipping of derricks guys, and 'lazy guys' as the derricks are drawn towards the cargo being lifted; the yelling of top-hands and bull-winch men, issuing their orders; and above all, the blasting of merchant ship's sirens, as vessels enter or leave the docks was immense. Then, of course, there are tug boats and motor launches, hooting and tooting. Men themselves created a racket above the noise of ship's working machinery, that emulate religions taught versions of the devil's damned spirits, as they writhe in their self imposed hell in purgatory. Well, that's what religion had been teaching us.

The ship we were working on was a cargo passenger vessel of the West African coastal trading conference line. It was tied up (berthed) to bollards by her stem and stern (there were no springs holding her mid-ships) to her berth in Tilbury Docks. Between the ship and the quay was what is known in the docking industry in London as a dummy (a pontoon), that was wedged between the ship and the quay. It was, in fact, both a floating fender and buffer, installed to allow freight carrying lighters or barges to be floated between the shore-side of the ship and the quay, whether they were discharging or loading freight.

The main imports brought into Tilbury Docks by West African coastal trading vessels during the late 1950s (West African Coastal trading conference line vessels transferred from the Pool of London to Tilbury Docks, in 1956, a move that brought the first long term regular employment to the men of the 'down river' docks) were in the main: logs and cut timber; ground nuts; cocoa and coffee beans; palm kernels and palm oil (a commodity prepared from the Guinea oil palm, which either came in solid form, packed in wooden cases, or as liquid oil that was imported in a ship's deep tanks, which on its arrival in Tilbury docks was pumped out into specially built small tankers); chests of tea; and yams and bananas when they were in season.

Logs, imported from West Africa, came in various lengths and weights, just as they had been cut in the jungle. Some logs still had their jackets on them (bark that is), while others came naked (without the bark). The weight of the logs varied too; anything between one and fifteen tons, or more. However,

the weights shown on the ship's manifest were those calculated by the timbers known density, not by having been weighted on a scale. So if a logs weight was calculated by the measurement of its thin end, as opposed to its middle girth, it was not unusual to get a manifested weight of a log showing 10 tons, when its actual weight was 12 or 14 tons, or even heavier.

Now I'm sure you understand that not only were ship's gangs cheated out of piecework earnings, their very lives were put in jeopardy. This was simply because the wrong lifting wires or chains were quite often used in the discharge of these monstrous logs. For when wires snapped or chains broke they occasionally caused injuries and sometimes the deaths of those men who were using them.

(Now in case you are unaware of the 'piece work rate' paid for the discharge of logs imported from West Africa, I have to explain dockers and stevedores as 'piece-workers', were paid four shillings, seven and a half pence per dead weight ton for discharging heavy logs. This payment was shared equally between a ship's gang members. A ship's gang comprised twelve men, as laid down under a 1932 Tariff agreement, made between The London Ship Owners' Dock Labour Committee, the Transport and General Workers' Union, and the National Amalgamated Stevedores and Dockers Union. So the actual money wage received by each member of a ship's gang, for every ton of logs discharged, was four and a half pence per man, or two new pence per ton per man in today's money value.)

Perhaps, for the benefit of those readers who have little knowledge of conventional highly skilled, labour intensive dock work, or are honest enough to accept they have no knowledge at all of such work, I should explain the reason cargo ships were berthed against a dummy – so that both shore quay cranes, and a vessel's own winches and derricks could be used in the discharging or loading process. Such equipment was more generally used on operations where liners ran to a schedule, as opposed to tramp steamers and short sea trading vessels, which put to sea as soon as the loading or discharging operations were completed.

The ship I was working on this particular day, as I've previously pointed out, was a West African coastal trading vessel. She had five holds, two forward and three aft. I was working at Number 4 Cargo Hatch with my usual ship's gang, using ten-ton winches and derricks. We had finished discharging the upper 'tween deck of five hundred tons of palm kernels into Thames lighters. The down-holders had removed the 'tween deck hatch covers, and we winch drivers had lifted the 'tween deck beams and sister beams out of their couplings, placing them in the 'tween deck, ready to break out the first log from the lower hold. That was, of course, as soon as the 'bull-winch man' had raised it up, and a lifting wire had been secured around it. But by anyone's standard it was a very large, round, heavy log. George, our 'down hold foreman', asked the O.S.T. clerk what weight was indicated on his log sheet:

'Nine tons,' he replied.

'Nine tons my foot,' replied George. 'We had better put a 12-ton lifting wire round that log,' he ordered, 'and use a 15-ton shackle to reeve it.'

A 12-ton lifting wire was promptly dragged across the 'tween deck, dropped into the lower hold, and placed under the log. Then the 'bull-winch driver', having raised the log for a 12-ton lifting wire to be wrapped around it, lowered the log back into its coupling. When the log had been revved and secured to a 15-ton shackle, we winch drivers lowered the union purchase, and on the top-hand's signal we began to raise the log up out of its coupling to just about the deck hatch height, ready to swing it out over the ship's deck, to be placed in a Thames lighter that lay alongside the ship ready to receive it. The log, however, had got no higher than 10 feet off its stowage, when there was one hell of a crash. The wire holding the derricks head in place snapped, as did the 'guy' and 'lazy guy' wires. This caused my derrick to crash down across the centre of the open hatchway, changing it from straight to banana curved. At first, after the crash, there was complete silence except for the vibrations coming from the fallen derrick and the grating

of the broken wires as they wreathed about like dying anaconda snakes round the ship's deck and 'tween deck. It was then that George's ex-Regimental Sergeant-Major's voice roared out:

'Everyone all right?' A chorus of voices from different parts of the lower hold called back, 'Yes, we're OK,' or non-endearing words to that effect.

However, in some cases there was that sort of language that irate bishops are said to use only in a private conversation that is designed to bring reddening on the faces of malfeasance clergymen. In the docks, however, the language was quite often a little more colourful. For example: 'No bloody thanks to that stupid bastard, whoever it was, that calculated the weight of that sodden Log. That derrick could have killed the bloody lot of us.'

While we all stood around for a few minutes, absorbing the shock of the ship's derrick crashing down across the ship's hold, the company's Shore Captain came striding up the ship's gangway. He wasn't in the best of moods; in fact he was in a controlled rage. At first he said not one word as he surveyed the damage, inspected the derrick's lifting wire, and the broken frayed 'guy' and 'lazy guy' wires, then ran his eyes along the derrick. By this time the ship worker and 'ship's gearers' had turned up on the scene. They stood behind the Shore Captain, who turned to them and uttered these unforgettable historical words with venom aforethought:

'Bloody Luddites, the lot of 'em, that's what they are. Bloody Luddites.' Then he scratched his head, as he stood in silence for a few seconds, deep in thought, before he began to bark out his orders like the professional merchant sea captain he had been.

'Right,' he bellowed to the gearers, 'put that undamaged derrick back into its crutch, clear all the broken wires and coil them up. Have them put ashore and sent to the shore gear store for examination. The lifting wires on one winch is OK, so you can leave that in situate, but the guy and lazy guy lines shall have to be replaced.' To the ship worker he said: 'You had better get the ship's crew to release the broken derrick from its coupling, put two twenty foot lifting wires round it, one on each end, for a quay crane to remove it onto the quay. I'll go ashore to arrange for a replacement derrick to be brought here as quickly as possible.' With those last few totally irrelevant words (he was, after all, talking to professionals, who knew the answers to the problems equally as well as he did, and who also had the know-how and skills to repair the damage) he disappeared down the ship's gangway, to make his telephone call to get a new derrick and guy wires delivered to the ship, while the ship worker and the gearers got on with their job of clearing the wreckage and repairing the damage. Not a word had been said about the reason for the calamity that had been caused by the over-weight log.

Terry in the meantime, our 'ship's gang' member with a university degree, who was reputedly a communist sympathiser, had retreated to the ship's side in the 'tween deck. He was leaning nonchalantly with his back against the stringer boards, reading the *Daily Worker* (or was it the *Morning Star*) newspaper, apparently oblivious to the frenzied work of the 'ship's gearers' going on about him, who were engaged in clearing up the jumbled mesh of steel guy wires that had been let fall from the derricks head into the hold, where it was considered to be safer to wind them into coils ready to be put ashore.

George, our gangs down hold foreman, was standing at the end of the log that was the cause of the calamity, reading the log and tin-tally numbers. (Tin-tallies are metal discs that were nailed to the end of logs, tags that should enable the O.S.T. clerk to identify the number painted on the end of each log. Tin tallies and log numbers are copied from a ship's manifest onto discharge 'log sheets' for identification purposes, before delivery to the merchant owners. The O.S.T. clerk, who is responsible for checking the tin tally and log numbers do so to ascertain which import merchant each log belongs to.) The O.S.T. clerk had come down into the 'tween deck to clarify the stated weight of the log that

was shown on his ship's discharge papers, which were copies from the ship's manifest. The log was listed as weighing 9 tons.

'They don't correspond, the tin-tally and the log number,' the O.S.T clerk told George. 'The log number on the discharging log sheet gives the weight as 14 tons, but the tin-tally number is shown against a log that weighed 9 tons.'

'So you took the tin-tally number, not the log number, is that what you're saying?'

'Yes, I did, it's easier to find the tin-tally number than the log number on the discharging papers.'

'Well don't bloody do that again, you stupid sot,' George threatened, waving his fist in front of the O.S.T. clerk's nose. 'Some of us may have been killed or injured when that derrick decided to visit us down here in the hold.' He then changed the subject by calling out to the tea-boy, 'make a pot of tea, Brains, and don't forget you've got the gearers to cater for,' then George walked over to where Terry was reading his *Daily Worker* Newspaper.

'What are Bloody Luddites, Terry?' he asked.

Terry folded his newspaper, put it in his pocket, raised his hands over his head, yawned, stretched out his arms, stuck out his tongue and licked his lips, then replied:

'Luddites George, not bloody Luddites.'

'Then what are Luddites?'

'It's more a case of what were Luddites, George. Luddites was a name attributed to the anti-machinery rioters of the early nineteenth century. They got that name from a Leicestershire fellow, a chap who called himself King Ludd. Ludd is reputed to have signed public letters, denouncing the new powered machines. His agitation led textile workers in the Midlands to destroy power looms and knitting frames, because mill workers believed the machines to be the cause of mass unemployment in the cotton and woollen industries.'

'Oh!' exclaimed George, 'that's what that cheeky sot meant, is it. I'll have to have a word with that Shore Captain when he comes back aboard here.'

In the meantime, while this conversation was going on, Brains had returned with the teapot. The rest of the down-holders, now armed with mugs of tea, gathered around Terry and George, listening fervently to their conversation. Then Brains said:

'I didn't hear the beginning of your conversation, Terry. But I did hear you mention Luddites. What did you say Luddites were?'

'Destroyers of machinery.'

'Is that what that Shore Captain meant when he called us Luddites?'

'Yes Brains, he did. But we're not Luddites. Luddites deliberately destroyed machinery to protect their jobs. As it is we haven't caused any damage to machinery, what damage was caused is due entirely to whoever it was that miscalculated the weight of that log in the African jungle, and nailed the wrong tin-tally on it, thousands of miles away. A foolhardy error that has stopped us from carrying on with our jobs.'

Terry was then asked by another member of the ship's gang: 'Were there any other groups of Luddites recorded in history, Terry? '

'Yes. Lots of them,' Terry replied, 'although there're not referred to as Luddites. What's more, they were not workers trying to protect their jobs. Most of them were in the military: navy, army and air forces. But I would also include ship owners in that category. Unscrupulous, money grabbing men, who sent what were known as coffin ships, complete with cargoes, to sea in the full knowledge they would never make it to their destinations. Their intension in this was, of course, in claiming Loss Insurance on the ship and its cargo.'

'Give us a few examples of the sort of men you are talking about,' said George.

'I don't know where to start really, or who to include. There was a Chinese Emperor, whose name I cannot remember, who in 213 BC ordered the burning of all classical manuscripts. Books that contained Chinese history and inventions. It was an outrageous act that put Chinese social and inventive progress back hundreds, or even thousands of years. But that wasn't ludditism in the true meaning of the word, because that was about the destruction of accumulated knowledge, not machinery. Yet another catastrophe that could be put in that category was the invention of a machine by a bloke called Babbage.'

'Who was he? What did he do?' Brains asked.

'Charles Babbage (1791-1871) was an English mathematician, who was born in Totnes, Devonshire. He was at first a student, then lectured for a number of years at Cambridge University,' Terry explained. 'He compiled the first actuarial tables and designed a mechanical calculating machine that is now said to be the forerunner of modern computers. The machine wasn't built, because the government of the day refused to fund its construction. This was even though the Royal Society had recommended it should do so.'

'What were the government's grounds for refusing that advice, especially as it came from such a distinguished authority as the Royal Society?' said Brains to Terry's bewilderment.

'I think it was argued by some politicians in the Tory government of the day, they could build three battleships with the money it would cost to construct the Babbage calculator. It was either that, or for some other stupid excuse. That to my mind was yet another one of the most stupid and despicable acts, perpetrated by numbskull politicians against the advancement of scientific and engineering knowledge. Knowledge that would have benefited the advancement of the human race, an act that overshadowed even the stupidity of the Chinese Emperor, who ordered the burning of books. But neither is that, in my humble opinion, Ludditism in its true sense.

'However, to my mind, the greatest Luddites were all creators of recent modern history. For there were the Generals and Field Marshals of the First and Second World Wars, whose major claim to fame was due to the destruction of their enemies field equipment: tanks, guns, aircraft, ships and factories. Those that come freely to mind during the Second World War are Field Marshals Rommel, Zhukov, Montgomery, and Generals Guderian, Patton, Bradley and MacArthur, while they were in command of British, American, Russian and German land armies.

'At sea, on the other hand, a convoy of merchant ships on its way to Russia in July 1942, Convoy P.Q.17, lost twenty-six of its ships to German aircraft and U-boats when Royal Navy surface ships were ordered to abandon the convoy, and for the merchant ships to scatter. It was a disastrous order said to have been made by the First Sea Lord, Sir Dudley Pound. Even though it is known on advice from Bletchley Park cryptologists, through Enigma decrypts, that *Tirpitz* was expected at Altenfiord; she was not making for Convoy P.Q.17. Therefore there was no immediate danger to Convoy P.Q.17 from the German battleship *Tirpitz*. So, was it Sir Dudley Pounds own decision to abandon Convoy P.Q.17, or was it on an order to him that came from some other source within (or without) the War Cabinet, so as to stop the convoy's supplies from getting through to the Russians, for which Sir Dudley Pound has had to take the blame?'

'Don't be so damn stupid, Terry,' George replied angrily. 'Who would give such an order? What could be gained by it? Who would benefit from it?'

'H'm! Well! Just think about it. What a way to kill two birds with one stone. Two socialist political systems hated by leaders of the Western Alliance that were set to battle it out between themselves on the Russian Steppes. Conveniently, I may add, thousands of miles away from Western Alliances battlefronts. Supposedly, I may add, leaving the Russian's without the appropriate modern military hardware to counter the German invasion of their country. Now can you tell me who among Western

Leaders could resist such a God given opportunity to undermine the fighting ability and destruction of at least one of their political enemies?'

'What are you saying, Terry. That western war leaders would sacrifice all those ships, and all those men, to weaken one of those two socialist political systems they hated?'

Terry shrugged his shoulders, waved his hands and continued, 'Well, why not? But if I'm right it could argue that was the result of the actions of a politically motivated Luddite, or Luddites, for which Sir Dudley Pound has had to take the blame.'

'So why wasn't Sir Dudley Pound 'Court Marshalled'? Isn't that what the navy always do when officers lose their ship?' said George.

'Because Churchill, the Prime Minister, accepted his resignation on 10 September 1943, and Sir Dudley conveniently died on October 21,' said Terry. 'So we will never know the 'whole truth and nothing but the truth' as to why he made that disastrous decision.'

'Then,' continued Terry, 'there was the attack on Pearl Harbour by a Japanese fleet Task Force, on 7 December 1941, under Admiral Yamamoto, when he ordered over three hundred Japanese aircraft to take off from Aircraft Carriers, which then bombed and sank most of the American Pacific fleet in Pearl Harbour, Hawaii. This action occurred on 7 December 1941, and killed over three thousand American service men in the process. But to my mind, the greatest Luddite of them all, was Winston Spencer Churchill (1874-1965), the 1940-45 wartime Prime Minister of Great Britain.'

'Churchill!' gasped George, 'Winston Churchill our revered wartime Prime Minister. Why you damn communist agitating bastard. What's made you make such a scurrilous statement?'

'Because George, it was Churchill who ordered the destruction of Tommy Fowler's Colossus Machines; machines that can be described as the first "workable computers", when the Colossus Machines were in use, during the Second World War. Churchill is reputed to have said of them: "they're the geese that laid the golden eggs, and never cackled." But after the War had ended, on Churchill's orders, the Colossus Machines that had been built by Tommy Fowler (1905-1998) to unravel the complexities of the German Enigma coding machines were destroyed. They were smashed into pieces, it's recorded, no larger than a man's hand. Why do you think he did that? What was his motive? By anyone's standard that must rank as the most outrageous, stupid, single act of futuristic electrical engineering vandalism, in the history of mankind.'

'Did Churchill really do that, Terry?' said Brains. 'Why do you think he did that?'

'Because Brains, Churchill may have thought the Russians would get hold of the technology. But whatever his reasoning, it brought about the destruction of the first workable electronic decoding machines; machines that would come to dictate man-kinds future; machines that would make it possible for men to travel in space. The Colossus machines were the forerunners of modern day computers. Churchill must have realised that potential. But his foolhardy order, as far as we British are concerned, was even greater than the political decision made in the early nineteenth century, that I've already mentioned, which refused to fund the construction of Charles Babbage's calculating machine. More especially so as Americans at the University of Pennsylvania, were soon setting about designing and building a similar machine which they called ENIAC.'

'Where do you think the Americans got their idea for building a machine similar to the Colossus?' Brains asked.

'Well, I'll give you one guess. There were half a dozen American cryptographers who had been attached to Major Ralph Tester's code breaking team at Bletchley Park during the Second World War: Alan Turin; the mathematician Bill Tutte, who broke the Tunny (Enigma) system in 1942; Jerry Roberts, a cryptographer; and, the pioneer of modern computing, Tommy Fowler. So I expect that

when they got back to America, and were de-briefed about their experiences at Bletchley Park, they revealed to their interrogators what they knew of the secrets of Colossus. As you know, the Yanks are not backward in coming forward. They must have quickly realised the value of such machines. What's more I'm not too sure of Churchill's motive with regard to his order, or what reason he may have had to order the destruction of Tommy Fowler's British Colossus machines.'

George laughed and said, 'you stupid communist idiot. What! Do you think Churchill was an agent in the pay of the Americans?'

Terry shrugged his broad shoulders before he replied. Then he said, 'Well he gave the yanks most of the secrets of Britain's wartime inventions to them: radar, the jet engine, penicillin, etc.'

'He did that to help us win the war,' replied George.

'Did he?' said Terry. 'Then why didn't he give those same secrets to the Russians and the Chinese?'

George scratched his head before he replied. Then he said, 'Yes! That's a thought. I wonder why he didn't?'

It was during Terry's vitriolic gambol on the non-working class Luddites that the Shore Captain came down through the deck hatch into the 'tween deck. He was still fuming in a controlled rage, but George wasn't going to give him a chance to verbally lambaste any of us. Well, at least not for the damage to the ship's derrick and guy wires.

'I've been waiting for you to come back, Captain,' he began, 'I've got a bone to pick with you.'

'Have you now,' said the Captain taken by surprise at what he no doubt thought was temerity on the part of this lesser being, 'and what may that be?'

'The weight of this shipment of logs.'

'What about them? Are you blaming the logs for all this damage?' he said waving his right hand about him, over the cargo.

'Certainly not,' replied George, 'but I am blaming whoever it was that recorded the weights of these logs in Africa.'

'What do you mean?' the Captain said.

'Well, the log weights don't match up with the tin-tally numbers.'

'How do you know that?'

'Because I've had the O.S.T. clerk down here with the discharging log sheets. We've been checking the log numbers against the tin-tally numbers. They don't match.'

'What's that got to do with the log weights?' the Captain growled.

'That log we've got reeved ready to discharge is recorded to weigh 9 tons on the log sheets tin-tally, but against the log number its weight is said to be 14 tons.'

The Shore Captain looked at the log then turned to George, 'You've been discharging logs long enough to know from experience, that that log obviously weighs more than 9 tons.'

'Yes,' said George, 'I do, that's why there's a 12 ton wire round it, and its reeved through a 15-ton shackle.'

'Oh! I see,' replied the Captain as he stood staring at the offending log, 'what do you suggest we do about it?'

'Well now,' said George. 'First thing first. How did the dockers on the West African Coast manage to get these overweight logs aboard this ship with ten ton lifting capacity winches and derricks? Second thing second. We're going to have to take it ashore and weigh the damn thing. Third thing third. How do you propose we manage to do that with 10-ton lifting derricks?'

The Captain was in pensive mood, and then he said, 'I'll order up a floating crane from the Port Authority to take the heavier logs out, do you know how many there are?'

'According to the O.S.T. clerk's discharging papers, taken from the ship's manifest, there are five or six of them and they're all on the top stowage.'

'Then I'll go ashore and order up a Port Authority heavy lift floating crane. It's in the docks now at 34 shed. If I can get it over here on the quick we'll be able to get those heavy logs out of the hold and into the craft, by which time the new derrick should be installed, the guy wires in place, and we should be ready to get back to work.'

George smiled then said, 'We, Captain? I think you mean you,' and he waved his hand in the direction of his ship's gang.

The Shore Captain said not another word. He quickly climbed up the 'tween deck ladder and disappeared through the deck booby hatch cover.

It was about half an hour later that the Port Authority heavy lift crane *Atlas* pulled up against the ship's side. After a brief word or two with George, the *Atlas* floating crane crew installed a weighing machine on the end of the crane's hook, and brought it over the ship's hold to pick up the first log. We all got a shock when *Atlas* took the log's weight, and it was seen to register 16 tons; the other five logs in the merchants parcel weighed much the same. George was fuming. He sent Brains over to the shipping company's office, to fetch the Shore Captain.

When he arrived back on the ship's deck, the Shore Captain blurted out, 'Who gave you permission to have those logs weighed?'

'I did,' said George, 'and everyone of them is tons heavier than shown on the O.S.T. clerk's log list. But don't you worry Captain, I know what they've done. They've put the wrong tin-tally number on each log, to confuse us as to its true weight. If it hadn't been for the fact the ship's winches wires and derricks weren't up to lifting the logs, the perpetrators of this scam would have got away with it.'

'Yes George, you're possibly right,' the Captain agreed. 'I'll send a report to our shipping agents on the West African Coast about this incident, and I'll get the tonnage clerk to record those extra weights on your piecework tonnage sheets. I'll see to it you get paid for the extra tonnage.' The Captain then made his way back up the 'tween deck ladder, and disappeared through the booby hatch onto the ship's deck with George calling out after him:

'By the way, Captain. Terry has explained to us what you meant by Bloody Luddites. If you don't come up with that extra tonnage for those over-weight logs, plus the lost day work time, you will find out just what sort of bloody assassins we can be.'

The Captain looked over the deck hatch, and smiling down at us from the safety of the deck hatch combing said, 'I'm sure I will George. I'm sure I will.' Then he hurriedly made his way down the ship's gangway so as to let us dock working labourers get on with the clever job. That being, of course, getting his West African Ocean Trading ship's valuable cargoes of ground nuts and logs discharged.

Postscript

It was many years after Terry's 'down hold lecture' aboard a discharging West African deep-sea coastal trading vessel, or to be more honest a tirade based on the subject of Luddites. His theme was the destruction, on Winston Churchill's orders in 1945, of all but one of the Colossus Machines (that one having been moved to GCHQ at Cheltenham), mechanical devices constructed by Tommy Fowler (a post office engineer who designed and built the first workable computers) when he became a member of Major Ralph Tester's team (recruited on the advice of a Max Newman) of code breakers, stationed at Bletchley Park. It was a team that had previously been more or less decrypting messages long hand, which were sent out by the German military through their Enigma-encoding Morse transmission machines. The

Tester team included the mathematician Bill Tutte, Alan Turing and the cryptologist Jerry Roberts, before being joined by Tommy Fowler. The argument Terry put forward was that the destruction of the Colossus Machines was the act of a Luddite, suggesting that Churchill was the greatest Luddite in history.

However, I had forgotten all about Terry's tirade on Luddites, when I chanced upon Tommy Fowler's obituary in *The Times* dated Tuesday 10 November, 1998. So my interest having been reawakened on such a historically important event, I telephoned Bletchley Park to enquire about Tommy Fowler, and asked if the people there could give me any more information on the man. The reply I got was, 'We have never heard of him. Who did you say he was?' I put the telephone down in disbelief and disgust.

The Port of London Authority floating crane *Atlas*, loading a heavy lift off a Pickford's road trailer to be loaded onto an exporting vessel in Tilbury Docks, *c.* 1960s.

An F. T. Everard Coaster and Short Sea Trader out of Greenhythe, North Kent, *c.* 1950s.

TALE 9
They Called Him Flash

His surname was Lightning, but in the docks he was known as Flash. He was tall and slim, about 6 foot 3 inches tall, though his slimness made him look taller than he really was. He had light brown hair that was beginning to go a brindled gingery grey colour around his temples, but the top of his head was bald at the crown, due without doubt to five years of wearing a steel helmet as an infantryman with the British army, that had worn his hair away. Flash Lightning also had drawn features, that one could better be described as gaunt. He had steel-grey blue eyes that were a physical feature inherited, no doubt, from his Anglo-Saxon forebears.

Flash was one of a class of army veterans who rarely spoke to anyone. Not because he was in anyway unfriendly. It was just his way of hiding himself within himself. Other dockers who had had similar war experiences as Flash understood that, for they too, like he, had been through a bloody war and it showed on all of them.

Flash was one of those young men who had been 'called up' to the militia in March 1939, when he was just nineteen. He had been given a preliminary infantryman's training, and when war was declared on Germany, on 3 September 1939, he had been sent to France with the British Expeditionary Force (BEF). He had fought with the BEF in its bloody, unwieldy retreat to the north French Coast. A short lived battle once the German Army, ably supported by its air force, had launched their blitz against the Belgium, French and British armies in May 1940. Flash considered himself to have been lucky when he was rescued from the Dunkirk beaches, by a Gravesend based William Watkins owned Thames tug. He was landed at Ramsgate, on the south-east coast of England, from where he was dispatched to an army transit camp for retraining, before being sent home on embarkation leave for two weeks. On returning from leave he was then dispatched by troopship to North Africa, where he joined General Sir Archibald Wavell's Imperial Army of British, Australian and New Zealanders, who were already engaged in battle with the Italian army.

Field Marshall Sir Claude Auchinleck took command of the British and Commonwealth's newly formed 8th Army, in North Africa. Flash served under him in the Western Desert till Sir Claude was himself replaced by General Sir Bernard Montgomery. Flash then fought under Sir Bernard's command at El Alamein, as a private soldier with the Essex Regiment. When the 8th Army had broken through the Axis defence lines, he had followed the retreating Germans and Italians with the formation, across Libya to the coast. (It was a route he had come to know very well, simply because he had been back and forth along it enough times being pursued, then pursuing the Axis Armies. That was before Sir Bernard Montgomery had taken over command of 8th Army.) It was in Libya that many of General Erwin Rommel's Afrika Korps soldiers had been finally encircled, and forced to surrender.

Flash had taken part too, in the invasion of Sicily and Italy. He had neither been proud, nor offended by Lady Astor's assertion in the British Parliament, when she described British soldiers of the 8th and 5th Armies as 'D-Day Dodgers'. He had only wished she had been there with him and his comrades, so that she could have shared in the delights of the mud, blood, and death that went on in those high-

jinks days, weeks and months he and his comrades had spent in capturing Sicily, then fighting their way up the whole length of sunny Italy into Austria.

Flash was just thankful that after five years of serving his King and Country in foreign lands, and having been confronted by every conceivable danger in which he had lost so many of his mates who, like him, had sacrificed their youth and many of them their sanity or their lives, that he had made it home.

Home, however, was his parents hovel, set among the terraced slum areas of the bombed wastelands that surrounded the docklands of The Port of London. It was a place he had known well before the Luftwaffe had carried out a great deal of demolition surgery from the air in 1940 and 1941, and laid flat large areas all around his old haunts among the back streets and alleyways, where he had been born and grew up. It was a place that once again, now the war was over and the bombing had ceased, offered relative safety to him and his family, even in their impoverishment. The docks were the place where his father had worked all his life, since he had been discharged from the Army in 1919, and where Flash himself would live and work on a wage slave's existence after he had married and had children of his own, until he was killed in the obscurity in which he had lived. Flash, you see, wasn't the type of chap who would ever have asked for, or demanded, more. For as far as he had ever been taught or known, what he had was his sole birthright and his only entitlement on this earth – nothing more.

Flash had been lucky during the war, and had had numerous narrow escapes from death, but wasn't to be so lucky in civilian life in the docks. His father was a hatchway man who picked up ship's gangs on the 'Free Call' in the Dock Labour Compound for a stevedoring company, and Flash worked with him as a pitch hand. (Pitch hands were members of a 'ship's gang', and were responsible for preparing cargo that was being made ready to be loaded onto a ship.)

Flash was so indescribably skinny one wondered how he ever managed to get a pair of dungaree trousers to fit him. That was till he bent down and one noticed a large wedge shaped piece of material had been cut out of the buttock of his trousers. Even then, the dungarees that he did wear were hitched up at the waist in plaits, and held in place with an old army belt that had followed him home from his foreign engagements with the King's (not his) enemies.

One had to wonder, given his antecedents, how Flash had managed to get through five years of war without a visible physical scratch. Yet back home, in the docks, he often managed to get himself injured against all the laws of averages. Or perhaps the averages were beginning to even themselves out with those he had managed to avoid during those hectic days among the desert sands of North Africa, the mountains and valleys of Sicily and Italy, and finally Austria. While humping an army back-pack, a Le-Enfield rifle, a bayonet, and 50 rounds of .303 ammunition.

When I first worked with him, I wondered why an old man such as he was still slogging away working onboard ships, not realising he still had a young family to support. He looked to be about sixty. In fact, he had just celebrated his thirty-fourth birthday. I was working with him in railway trucks on one occasion loading a General Steam Navigation short sea trader, with stores for the British Army of the Rhine. The rail trucks held sections of Bailey bridges that were stowed lengthways. The sections were between 12 and 15 feet in length, 4 to 6 feet high and about 6 to 8 inches wide, and weighed about half a ton each.

We had sent several sections of a Bailey bridge aboard a ship, creating a space between the remaining sections and the inside of the wagon, when the rail truck we were working in lurched and the remaining sections tilted over, trapping us against the inside of the wagon. Flash had his docker's hook in his belt, and as we were both jammed against the inside of the truck, Flash's hook was rammed into his back by the weight of the bridge sections. When the other gangs' pitch hands had managed to free us, Flash had to be rushed off to hospital to have the wound in his back seen to. But as one of the dockers remarked after the accident, somewhat bewildered, 'How was it that Flash was injured and you wasn't? After all

you must have taken most of the weight of the bridge sections. You're twice as thick round the body as him.' That, unfortunately, was the way things went with Flash.

Flash went on working as a pitch hand with his father's gang till the General Steam Navigation's short sea trading boats pulled out of Tilbury Docks. He then got a job working with Big Dave's ship's gang as a down holder, labouring in ship's holds.

Flash had been working with Dave for two or three years before his luck finally ran out. Dave's ship's gang had been discharging, using the ship's union purchase on a cargo of heavy logs, lifting them from out of the lower hold and placing them into Thames lighters and canal barges berthed on the port side of the ship. They had finished discharging for the day, when the last available barge for loading had been taken by another gang. It was about 6.30 p.m., so Dave had decided to cover the hatch up for the night.

The gang had put the beams and sister beams into place, and were putting the hatch boards between the beams when the hatch board Flash was standing on came out of its coupling, and plunged him into the bottom of the ship's hold onto the logs below. He was killed instantly. He was just a bag of broken, crumpled, flesh and bones. The 'blood wagon' was sent for and a Port Authority Police ambulance crew was soon on the scene, but there was nothing they could do but take Flash's body to the mortuary. So ended the life of a man who had given his all for his country, a thankless country and society that had done very little in return for him. There was no fanciful obituary in *The Times* or *Daily Telegraph* about his devotion to duty, or his exploits as a soldier, or the loving care he had for his family. In death, the only mention he received was in a local media paper that reported.

'At a Coroner's Inquest on a dock labourer who was killed aboard a cargo ship in the docks. The coroner recorded a verdict of misadventure.'

Please don't misunderstand the context of what one docker was heard to say on Flash's death, which was, 'Well, he got away with it for five years in the Army during his war service. His luck had to run out sometime. It's just a matter of who's next?'

Of course, the dockers had a 'bucket collection' for Flash's widow and children, as they did for all their workmates who were injured or killed. The last I heard, Flash's wife was seen outside the Trade Union Office, crying. I don't know if she ever received any compensation for the loss of her husband, or her children for the loss of their father. The shipping company's stevedoring contractor was fined a few pounds plus costs for having unsafe working hatches on the ship. The reason the fine was so low was because the Labour Contractor's barrister argued there were extenuating circumstances which were: their client was not responsible for the equipment on the ship, only for the working equipment they provided. The docker, a very experienced ship-hand, was himself in part to blame for his own death, for walking on what he must have been able to see was an unsafe hatch cover.

This argument did not go down well with the magistrates who heard the case when it was brought before the court by the Board of Trade under The Factories Act, 1937. Nonetheless, it mitigated a little in the dock labour contractor's favour, and helped to reduce the fine, and ultimately any compensation settlement that may have been finally decided for Flash's widow and children. However, one thing you may be quite sure of, the shipping company's legal team, working on behalf of their client, would have argued, and obtained, the lowest possible level of compensation for Flash's wife and family. This endeavour was drawn out over the longest possible time span (usually several years), as the legal team working on behalf of the shipping company and its labour contractor aimed to circumvent the maximisation of fees for their own legal practice, which of course ultimately meant themselves.

Oh dear me! I almost forgot the other old ruse used in the calculation of a widow and her family's compensation used by the courts: 'of course the woman is still young enough to find herself another husband,' or words to that effect. That, dear reader, is what is commonly known by us members of the wealth producing classes as 'Yea Good Old British Justice'. I know because I've had a dose or two of it myself.

TALE 10
Christmas Puddings – Boom-Boom

Old Percy was the 'top-hand' to a ship's gang, that were busily discharging returned army stores from one of the many former outposts of the old British Empire. An Empire that was being slowly melted down, and re-cast by its constituent parts into a Worldwide Commonwealth of independent self-governing nations. The British Commonwealth of Nations is an association of over seventy independent Nation States, dependencies and protectorates. The political status of the member nations is clarified and given legal substance under the Statute of Westminster, an Act drawn up in 1931 to form a Commonwealth of Nations, that was to be founded by the United Kingdom, the Commonwealth of Australia, New Zealand, Canada, the Union of South Africa, Ireland, Newfoundland and the Secretary of State for India.

The returned army stores included, among other items of cargo aboard the ship, cases marked DD. These cases contained the personal effects of British servicemen who had died, or who had been killed in action. The DD simply meant they had been 'discharged dead'. Among the cargo too, was a large quantity of surplus food, packed in cases and cartons. Now absolutely no one in the docks could ever make out why food stores, that were surplus to military requirements, were returned to the United Kingdom. Particularly when it was well known by the dockers discharging the stores, many of whom had seen military service in the countries from which the stores had been re-shipped, that many of the people in those places were near to damn-it starving. As it was, the shipping costs alone should have prohibited the return of such useless stores. However, Ordnance Supply Officers (OSOs), for inexplicable reasons, made contracts with shipping companies, through the Ministry of Defence, to fetch and carry armed forces supplies around the world, whether they were required or not. All the expenses of this policy were born by British tax payers.

In almost all cases, the surplus supplies would have been far better used, and appreciated, having being distributed as 'good will parcels' to the local inhabitants of the territories being vacated. Territories that had negotiated to become fully fledged members of The British Commonwealth of Nations, with the Queen of Great Britain at its head. However, quite possibly for some dubious political, cultural, or financial reasons, British taxpayers, through the ignorance or stupidity on the part of officers of the Ministry of Defence, acting on behalf of the British government, had to bear the cost of returning the obsolescent stores back to the United Kingdom (UK).

Now as I've already explained, this particular ship's cargo was a bit different from most returned army stores in so far as it also carried those dreaded black painted cases, each marked with a name, a service number, and on one side in large case black printed letters DD, meaning 'discharged dead.'

All the dockers in this ship's gang, without exception, had been in the armed services. One could sense their feelings of remorse because, but for the whining of the electric crane's motor some 80 feet above their heads, hardly a sound could be heard coming from the upper 'tween deck where they were working (no talking or banter among the men). That is except for the thump of dockers' hooks as they

were stabbed into the wooden cases and the thud of cases as they were turned over onto steel wires. These wires would bind the cases together as they were winged ashore by a 'Stoddard & Pitt' quayside crane, where the ship's side quay gang was standing by, ready to remove them by wheel barrows into the transit shed. There to await delivery to the army unit that would be responsible for forwarding them on to the deceased's 'next of kin'. As it turned out, there was only 50 to 60 tons or so of these cases. So when that consignment was finished being discharged, the lads cheered up a bit. Then after the gang had uncovered the wooden lower 'tween deck hatches and removed the steel main beams and sister beams, they began to break out the lower 'tween deck's cargo. The first cases of stores they found had been crushed, the contents spewed among the other cargo. To their delight the loose tins they found contained tins of corned beef, salted butter, and Christmas puddings. All they had to do now was procure a couple of loaves of freshly baked bread from the ship's galley and they had their provisions for a gluttonous tea break – best leave that to Old Percy. Old Percy soon resolved that problem by swapping a shilling piece for a couple of loaves of freshly baked bread with the lascar baker in the ship's galley, a coup that was quickly accomplished.

Now at this juncture in this tale it has to be explained that Old Percy, the 'top-hand' to the ship's gang, had left school in 1909 at the age of twelve, armed with that amount of academic knowledge considered by the government and industrial bosses at that time to be beneficial to any future employer and the State, but not enough education that would cause embarrassment to either at some future period in his life. In other words not enough education for him to be able to understand he was being physically used, mentally abused, and monetarily cheated by them.

On leaving school at the age of twelve, Old Percy went to sea. By the time of his fourteenth birthday he had been to half of the countries around the world, but he had never been taught to cook. He had left the merchant marine service at the age of sixteen years, and not having been able to find work ashore, he had foolishly joined the British army in March 1914. He was taught to obey orders on the pain of being lashed with a cat-o'-nine-tails, or being shot under 'King's Regulations'. During his induction training, he had been taught how to use and kill men with a bayonet, fire a .303 calibre Le-Enfield rifle, that could kill a man at half a mile range (he was in fact trained as a marksman – a sniper), and how to throw hand-grenades with the intention of wiping out machine gun nests in close quarter fighting. Neither the government, nor any of the members of the upper classes, on whose behalf he had been trained to kill in order to maintain their privileged positions in society, ever appeared to be the least concerned he should have this knowledge and ability. Nor were they ever bothered to see that he was taught to cook.

Soon after Old Percy's initial military training had been completed in England, he had been shipped over to Dublin in Ireland. Then in December 1914, he was sent to France with his battalion, to support the British Expeditionary Force (BEF), and the 'Old Contemptibles', who at that time were under the command of Sir John French. He served two years in the trenches in France and Belgium, where he had fought in the battles for Arras and the Marne. In addition, he was with the First Battalion, The Queen's Own Royal West Kent Regiment in the Battle for Hill 60 in April 1915, one of the bloodiest battles of the First World War. However, despite being taught to maim and kill, he'd never been taught to cook.

Old Percy had been wounded in the first Battle of the Somme, shot through the hand in the early morning of 1 July 1916. It was the day in which thousands of men and boys of the 'Chums Regiments' from the Mid-Shires of England, had been killed and wounded. Lives wasted in useless assaults on fortified German positions that had not succumbed to a prolonged heavy field gun bombardment. But at that time it didn't really matter to him that he'd never been taught to cook.

Old Percy recuperated from his physical wounds, but he never did get over the mental ones. He remained as near to lunacy as it was safe for the authorities to allow him to remain loose among society. However, as he spent most of his time at work in the docklands of the Port of London, sealed in behind high docks perimeter walls and fences, where he worked among so many other veterans with similar traumatic battle induced problems to his own – who was there to care? That was except for the lapse he had one day, when he struck a police officer. He had been brought before a bench of magistrates and sentenced to fourteen days in Wormwood Scrubs prison, where he worked in the prison kitchen and learned to apply salt to porridge in order to enhance its flavour. But other than that one single simple lesson in culinary preparation, he'd never been taught to cook.

However, after the fracas he'd been involved in during his two years in the trench mud of Belgium and France, and several months spent in a military hospital in Southampton, he was sent back to Dublin and an Ireland that was still seething from the troubles following the Irish Easter Rebellion of 1916. That's where he stayed until the war in Europe ended in November 1918. Old Percy was discharged by the army as medically unfit for further military duties; his discharge papers bore the statement on his military conduct as a soldier as 'fair'. But it made no reference to his inability to cook. For if it had it would probably have stated – no comment.

The assessment of Old Percy's military service career had been written by a chair-bound officer, a paragon of office efficiency, who had never seen action on the killing fields of France or Belgium. Haunted places where blood red poppies grew in profusion, as though they were paying their own tribute to the dead, after the guns fell silent. Although he had been discharged from the army in 1918, because of his war wounds, this did not stop the military from issuing him with a discharge book that contained a 'Railway Warrant' to take him to the nearest army camp in the case of a future National Emergency. This may have been because the army had had to spend so much time killing enemy soldiers, and in so doing getting its own men killed. Its Officer Corps had never found the time or reason to have Old Percy trained to cook.

Old Percy was, however, not only an expert at killing his fellow man on the battlefields, in the name of, and for the benefit of, his King and Country. He was also an expert at his job in the docks. He knew everything it was possible to know about discharging and loading ships. All those things he had learned which were of value to him, and port employers, he had had to learn himself. He could rig, raise and lower derricks. He could drive both electric and steam winches, and he could secure heel blocks and set up bull winches. As a young man he had been a 'down hold foreman', a 'ship's after foreman', and a 'ship worker'. However, as he was now old and nearing retirement, he had come down to being a 'top-hand' to a ship's gang. But during those years he had fought for his country, and the far greater number of years he had worked in the docks, he'd never been taught or learnt how to cook.

Now the gang he worked with had found out it was Old Percy's birthday, so they thought they would give him a treat. Having broached some tins of corn beef, salted butter, and Christmas puddings, they sent two large tins of Christmas puddings up from the lower 'tween deck for him to warm, and share between himself and the gang (as a birthday present you must understand). Now as you must by now know, Old Percy had never been taught or learnt how to cook. One of his prime boasts was that he couldn't even fry an egg (the truth was he couldn't boil one either). On this occasion he thought that sooner than be accused of a lack of initiative, he would give the culinary business a try, for it was his personal view that, 'it's never too late to learn.' So with that thought in mind he took the Christmas puddings to the galley and having put them in one of the chef's galley ovens he went back to the cargo hatch to control the crane driver, while the large tins of Christmas puddings were being heated up.

Now just in case you are unaware of the fact, galley ovens on working ships are always lighted and hot, this ship's oven was no exception. A few minutes after Old Percy had placed the tins of Christmas puddings in the oven, there were two almighty boom-booms. Men working on deck dashed into the galley to find the oven door on the galley floor and chunks of Christmas pudding splattered up the galley baulk-heads, over the floor and the galley ceiling. Pieces of the dessert were sticking to every conceivable nook and cranny. It looked as if the galley had been pebble-dashed with currents, raisins, lemon peel, nuts, and chunks of gooey brown pastry. The chef rushed in, saw the mess, stood stroking his chin, looked at the dockers, who looked at each other, then all their eyes focused on Old Percy. The chef's eyes followed them.

'Did you pierce the tops of the tins, before you put them in the oven? You silly old sot,' he asked.

'I didn't know you had to!' replied Old Percy, 'I've never been taught to cook.'

It was obvious the chef wasn't in a very good mood, as he stood by his galley door clenching his fists in more than a menacing way. Then he ran a finger up the galley bulkhead to scoop up some of the pudding. He licked his finger and smiled, 'H'm,' he said, 'not bad.' Then his face turned into a smile as he saw the funny side of Old Percy's dilemma. 'You lot can clear off back to work,' the chef ordered. 'I'll get my Indian galley hands to clean up this mess.'

As the men left the galley, one of them told the chef, 'It's Old Percy's birthday today. That was why we gave him the Christmas puddings.'

The chef told him, 'If it happens again, that old man will never live to see another birthday, let alone a Christmas pudding.'

At Mobile Time that same afternoon, the chef came down the hold with a large cake, 'That's for you lot to celebrate Old Percy's birthday.' Then he said in a lowered voice, 'By the way, the Captain's rather partial to tinned Christmas pudding.'

The down hold foreman nodded, 'Right,' he said. A nod is as good as a wink in any language. A deal had been done.

Then the chef said as he began to climb the ladder up through the deck hatch cover, 'by the way, keep that old blighter out of my galley, or I'll throw him overboard.'

'There's not a lot of good my going in the galley, anyway,' said Old Percy.

'Yes, I know!' replied the chef, laughing loudly, 'you've never been taught to cook, but I hope you know how to swim. How old are you anyway?'

'I'm sixty-eight today,' replied Old Percy, 'I have got to retire from the docks today.'

'That should be handy for you,' replied the chef. 'You'll be able to go to night school.'

'Night school! What for?' said Old Percy.

'Cookery lessons you damn old fool,' replied the chef. 'Don't you think at your age it's about time you *did* learn how to cook?'

Big Dave, Little Fred and the Grey Haired Old Woman

Big Dave, as he was known throughout the docklands, was indeed a big man. Yes, he was a giant by any standards. He stood 190 cm in height (6 foot 4 inches) in his stocking feet, and he weighed 160 kilos in his underpants (350 lbs). There wasn't one single ounce of flab on his huge body. He had a torso and limbs that resembled those of Garth, as he was depicted for many years in the *Daily Mirror* cartoons.

Now I have to emphasise here that Dave always carried a serious countenance on his large, round face, even during times when it was never meant to be. Anyone who didn't know him, or had little knowledge of him, would have taken him to be some poker-faced clown, or a funeral director. However, they would most certainly never have taken him to be a dock worker, except perhaps for his working clothes that may have been the only giveaway to his lawful occupation.

But beneath his stern countenance, Dave was one of the most benign, kindly, and gentle individuals anyone could ever wish to meet. He was truly a gentle giant, with immense physical strength that matched his huge frame; a strength that he must have had great will power, and considerable patience to contain on some very stressful occasions, as the following contents of this tale will show. Fortunately for some people, Dave also had an exceptionally good sense of humour, and could see the funny side of tense situations, at least those I was fortunate enough to be privy to.

Little Fred, Dave's friend of long standing, on the other hand, was a midget. He was a man who, when he was standing upright in his darned socks, stood at about 165 cm (5 foot 5 inches), and weighed about 52 kilos (115 lbs). Nor was there an ounce of flab on Fred, though he could well have done with a kilo or two more flesh on his frail little body.

So as you can see from his physical description, Fred was a poor, sickly looking specimen of a human being, with a pathetic physique that was mainly due to a lack of nourishing food as a child. During his working days, Fred worked as a lighter-man, taking lighters up or down the river Thames, to or from merchant's warehouses or wharves along the riverside; or propelling them across the docks from one berth or ship to another; or from one set of dock lock gates to quayside berths to be loaded or discharged; or to be towed out of the docks into the river.

However, in the evenings, when he wasn't at work on the river, Fred could be found busily working behind the bar of his public house, The Standard, where he helped his wife serve customers (mostly cronies he worked with) till closing time each night. Then, on the following day, he would leave his pub at 6.00 a.m. to be on the 'lighter-men's call on' at 7.00 a.m. It was, therefore, of small wonder Fred was always looking so pasty faced, malnourished, tired and ill. But one has to suppose that despite always looking pasty faced, undernourished, tired and ill, in himself he wasn't. On my diagnosis of his condition it was due in no small measure to the poverty in which he had lived during his childhood and youth, and the lack of adequate nourishing food consumed during those impoverished years, which caused his stunted growth and a rigor mortis type of physical action. It

has to be admitted that Fred was, to say the least, as poor a looking specimen of a man as he had been when he was a boy. He'd not grown much taller either, but what he lacked in physique, he made up for in mental acumen. For a man who had had a lot of schooling, but as was the case in his school days, very little constructive education, Fred had a sharp 'street wise' mind that he used to good effect when it suited him.

Now I have to admit the scenario to the events that follow are based on what little knowledge I have been able to muster from workmates, friends, and fellow travellers, on the fateful day of this tale. Therefore let me unravel this story in the way I have seen it through the eyes of other people; people, that is, who were witnesses to what must have been an hilarious event. Well, at least as far as the captive audience of Dave's fellow travellers were concerned.

Dave and Fred had been friends for years, bosom pals. They had grown up on the same council estate, and they had been in the same class at school. In fact, they were not dissimilar to Laurel and Hardy in size or mannerisms, the two screen comedy actors that dominated the comic acts in films shown in cinemas the world over, during the 1930s, '40s, and '50s, with farcical antics on film. Stan Laurel and Oliver Hardy had been their favourite Hollywood Stars, as they had sat in what was commonly known as the fleapit of the Plaza cinema in Windmill Street, Gravesend, when they were schoolboys. That had been their Saturday morning treat, before leaving school at fourteen. It was paid for by Dave's mother as a means of getting rid of both of them, so she could have a 'bit of peace and quiet' for at least part of the weekend.

Dave and Fred had stayed close friends until they were both called up for wartime military service. Dave was conscripted into the army, Fred volunteered for the Royal Navy. During the war they had both married before setting off on their military adventures, and through actions of war they went their separate ways. It was, therefore, on the rare occasions they met on such days as the one I'm about to describe, when they would reminisce, 'act the fool,' and play out the long ago memories of the days of their boyhoods, as though it was only yesterday. Almost everyone in the docks who knew them, or knew of them, were aware of the silly antics they got up to when they chanced to meet. But people who had no knowledge of them often found the slapstick comedy antics when they met, to say the least, damn odd for grown up men.

On the day of this tale, Dave finished work early, due to the ship on which he had been employed having completed its loading operations, and was on his way home. The vessel on which he had been working was at that instance being towed out of the docks through Tilbury Docks New Lock Entrance into the river Thames at Northfleet Hope. Dave, with his fellow Gravesend workmates, was standing on the Port of London's riverside ferry passenger terminal, waiting with a large crowd of other would be passengers for a ferryboat to take him across the river. It was a cold early evening in April, with rain clouds scudding along the Thames river valley. It looked very much as though it was coming on to rain.

A number of the office workers who were waiting on the ferry landing stage were sporting umbrellas, as were several other passengers that included an elderly woman who was standing close to Dave. She was a pygmy in size compared to Dave, standing something like 145 cm (4 ft 9 in) tall. She was also very rotund, that is to say fat or obese. She was continuingly glancing up at this man mountain out of the corner of her eyes with something akin to awe, or it may have been scowls on her face. No one other than myself, it appears, seemed to have noticed the ferocious glances she was making in Dave's direction, and she was too close to the jetty decking to be seen by or even to be noticed by him, or for that matter for him to care. Alas, it was at that very instance when who should come walking down the passenger access ramp but little Fred himself, Dave's tiny friend of yesteryear.

'Hallo, Big Dave,' said Fred.

'Well! Well!' replied Dave, 'if it isn't that human runt, Little Fred. The Tiny Tim lighter-man, and you couldn't get a lighter-man than you. Come here you puny midget, so I can box your elf-like ears.' He made as if to cuff Fred about his head. That was the signal the old lady had been waiting for to spring into action.

'Is this big lout bullying you?' she shouted at Fred.

'Yes lady, he's always bullying me. I've tried to be nice to him when we meet, but as you can see, he clips me on the ear.' With those few words Fred pretended to snivel.

'You horrible lout,' the old lady expostulated, and without further ado, she set on Dave with her rolled up umbrella. He just stood there, that colossus of a man, looking down at her with a frown of puzzlement on his face, as the old lady pummelled and lashed at his legs unmercifully, till she was on the point of near collapse. Her grey-blue dyed hair had fallen down over her spectacles, and her umbrella was broken in her hand with some of the canopy support spars sticking out like radio antennas.

Dave smiled down at her and said, 'What was that for, lady? I give in! You've bested me.' Then Dave turned round, scooped Fred up into the crook of his arm as though he was no more than a ventriloquist's dummy, and walked onto the ferry boat's gangway to the cheers and laughter of the other dockers, who had stood by to enjoy that unusual spectacle on the landing stage. It was a sight that left all the other ferryboat passengers bewildered, and the ferryboat captain roaring with laughter on his bridge.

'That was another fine mess you got me into,' said Dave mimicking Oliver Hardy.

'Yes! But what a vicious old hag,' said Fred, 'I thought she was going to kill you. Fancy being married to a cantankerous, vicious old battleaxe of a woman like that.'

'I am,' replied Dave, 'but it doesn't bother me.'

'No. I can see it wouldn't Dave by the way you stood up to her. You've obviously had plenty of practical experience,' replied Fred.

Dave smiled. He shrugged his massive shoulders before saying, 'Yes. I suppose I have Fred. But I never gave it a thought it would come in handy one day. It just goes to show you can never have too much practice. Well! Doesn't it?'

TALE 12
The Procurement Officer

Old Percy was just one of a large number of so called Artful Dodgers, who worked in the docklands of the Port of London. No doubt there were characters similar to him in all the other docklands throughout the world. For it was said of him that there was nothing he couldn't obtain illegally by the use of his natural cunning, intelligence and stealth, if he put his mind to any purloining problem, large or small. In fact it was often said of Old Percy he was a working-class Moriarty, without a Sherlock Holmes and Watson to pester his periodic inclinations towards any opportunistic criminal activities that offered themselves.

Old Percy had never considered doing a 'big robbery job' outside the docks. For other than his sea service as a boy at the age of twelve, and his First World War military service with the British army, where he had learnt to survive in and out of the trenches by his own natural intelligence, and the indoctrination training he had received in survival by experts employed for that purpose by King George V's military advisers, he had not had a chance. Except for that short period as a boy seaman, and his five years military service with the British army that was mostly served on the battlefields of France, he had always lived and worked in the nether world of London's shipping industry and docklands that lay within the hinterland of Old Father Thames on the Kent and Essex shores of England.

It was often said of him that had Old Percy been born into an aristocratic or land owning dynasty, he would without doubt have been seen as a highly intelligent chap. However, being a docker, and being the son of a docker, and having been born at the lower end of the social pyramid, he had to be classed as a cunning, devious, conniving scallywag – accepting that definition as the term used by 'Upper Classes' to describe people like him. It was generally felt among his peer group in the docks that had he gone to a public school, then into politics, he would certainly have become a Tory MP and Cabinet Minister. There were even a number of his workmates who were of the opinion that he may even have become a Prime Minister. 'Well,' they could often be heard to say, 'He's a big enough rogue and unprincipled scoundrel to fulfil that role.'

Old Percy's skills and adaptability at pilfering were legendary, and they were made even more remarkable by the fact that he was never apprehended. When he set out to procure something, anything, whatever it may have been, he never went for second best. Only the best was good enough for Old Percy. In fact, the circumstances, the need, and the environmental situation in which he had been born, brought up and lived had created in him the necessary aptitude and determination required to out-fox a fox. In other words his mind had adapted itself to that of the animal cunning required to survive within the un-civilised, 'wage slave culture' of the docklands. As surely as his distant forebears had had to do in the savage wild environment in which they had been born, bred, and were forced by savagery and brute force to survive. The environment in the docklands wasn't very much different.

Old Percy was also a master in the art of psychological connivance, a form of mesmerism he had developed, and which he very often used on selected subjects. It was a form of mental telepathy that manipulated the actions of those he was about to take to the proverbial cleaners. He would often practice his art on lesser intelligent mortals just to keep in practice, or for the simple fun of proving that 'mind and body manipulation' was possible on susceptible subjects, especially those supposedly educated, middle of the intelligentsia ranks, who he thought had tried to make a fool of him, or take him to be a fool.

There is a story about one of Old Percy's sons who had an interesting experience at school. This was at a time when families living on the council estate where he lived were going hungry, and mothers were taking anything they had of some small value to a pawn brokers, where they hocked it to get money to buy food, and to pay the weekly rent. Clothing was a poor third to food and rent on the working-class families' list of priorities, as they struggled for survival in the years preceding the Second World War. That was an even more obvious fact from the way many children, living in the privately rented slum dwellings around the Dockland, were dressed and sent to school. Soap, on the other hand, was an even poorer fourth on their list of priorities.

It was during a school lesson that one of Old Percy's sons was asked by his supercilious, authoritarian schoolmaster, 'What sort of cutlery do your family use at meal times?' (Most of the boys in the class didn't know what meal times were, let alone what cutlery was, or even what it was used for, or how it was used.)

Old Percy's son replied, 'knives, forks, and spoons, sir.'

'Knives, forks, and spoons, sir!' enquired the master in surprise. 'Do you know what metal the knives, forks, and spoons are made of if I may be so bold as to ask?'

'Steel and silver, sir!' came the quick reply.

'Steel and silver, sir! Steel and silver?' he echoed to himself almost in a shout.

'Yes, sir!'

The master turned towards the class and repeated the answer, 'Steel and silver, sir! I ask you. Steel and silver!'

The master's retort drew a burst of laughter from the class, which was what it was meant to do. Most of the boys had no idea what constituted a metal, let alone what silver was, or of its intrinsic value, with the exception of silver coins. But the master had achieved his initial objective, which was to bring ridicule on his pupil. (It was a teaching technique often used in those pre-war and wartime days, as a form of 'class' control both in its scholastic and social context.)

Then he said, 'And how do you know they are steel and silver?'

'Because they have silver hallmarks stamped on the handles, sir. And the knives have stainless steel etched on the blades, sir.'

'And what do the silver and stainless steel knives, silver forks and spoons you use have etched or embossed on them; the name Gerrards of Bond Street I do suppose?'

Old Percy's son in his childish innocence simply replied, 'No sir! It says P&O, sir.'

'P&O!' the master exclaimed in even greater surprise. 'So what does P&O stand for? Now come on boy. Don't be shy. Tell your class mates.'

'I don't know, sir.'

'I do not know, sir,' repeated the master. 'Then I shall have to tell them. It stands for Pacific and Orient Shipping Line.'

Another burst of laughter from the class, but this time they had every idea what they were laughing for, even though the teacher did not.

Then as an afterthought the teacher said, 'Do you have drinking glasses in your house?'

'Oh, yes sir!'

'Do they bear the symbol GVIR on them?' he said with a short laugh.

More laughter from the class, because they were now in tune with what the teacher was getting at.

'No, sir!' came the reply.

'Um,' said the teacher, 'I thought they might have had?'

'No sir, they've got GVR embossed on them, sir!'

The teacher shook his head in disbelief. He had given up. It was just as well he had because he'd suddenly realised he was treading on very dangerous ground, and he at least had enough intelligence to know it. The utensils were silver, they did have P&O etched on them, and the glasses did have GVR embossed on them. However, the cups and saucers in the house were not P&O. Old Percy had a 'hang up' against fine china, 'It's too bloody effeminate' he would say. So, all the cups and saucers in the house had SR embossed on them. SR was for Southern Railway, to whom they had belonged before Old Percy had decided to hold them in trust for the railway company, in perpetuity, or until they were broken. Then he would get more of them to hold in trust on the same long-term conditions.

Old Percy had had to learn about self-sufficiency while serving in the army. He was totally without scruples in relation to his methods of procurement. In fact, during his army service in the trenches during the First World War, he and his comrades had had degenerated into becoming psychopathic kleptomaniacs in order to survive. He was often heard to repeat what Roman Catholic priests are reputed to say to their congregations amid the slum districts throughout the world, 'God will provide.' However, then Old Percy would also add, 'and if He don't or won't. Well then, I shall just have to give Him a hand and provide for myself,' which he did without shame or conscience.

Of course, those experiences happened when he was 'Young Percy', in the years between the two World Wars, when he had a young family to support. He was one of those very rare breeds of men those days, whose family came first. If he could not afford what he deemed to be necessary requisites, then he was quite prepared to purloin them. He was a good provider for his family, but he was also very authoritarian and brutish, an unfortunate prerequisite in discipline from his service days. He was unloved by his children, but well respected by them out of fear. That was until they grew up and left home at their earliest opportunity, from which time they hardly ever visited him again. Work, therefore, was the only outlet he had left open to him, and he would scrounge for the ship's gangs he worked with, in the same way he had done for his unappreciative and thankless children. More often than not the gangs he worked with would refer to him as, 'The Procurement Officer.'

The ship's gang were still working on the same vessel Old Percy had blown the galley oven door off, and although Old Percy should have left the docks on his sixty-eighth birthday, he had been allowed to work on until the dockers had completed the ship's discharge. During this short lapse of time, the chef had more or less forgiven him for that incident. This was no doubt on account of the present of tins of Christmas puddings, donated by the 'down hold foreman'; puddings that had been salvaged from returned surplus army stores. That job had been completed a couple of days beforehand. The gang were now discharging granite kerbstones and tombstones 'over-side' into barges, working under the ship's derricks at Number 3 Hatch. The winches were set at the after end of the ship's hatch, facing the galley. The derricks were lying over the hatch at about a 30° angle so that the union purchase was plumbing the centre of the lower hold. There was a narrow walkway between the galley bulkhead and the edge of the ship's deck hatch combing. Enough room for old Percy to negotiate his way between the hatch combing and the ship's side to give his hand signals to the two winch drivers to raise or lower the sets of cargo.

In the galley bulkhead there were six portholes, these were always left open when the chef and his assistants were working. The chef and his galley staff were working on this particular cold and wet day, baking bread and cakes. The gang members working below decks were warm enough, protected from the inclement weather, the deck hands were not. The two winch drivers were wet through, and so was Old Percy the 'hatchway man'. 'Beer Ho' was fast approaching and the 'tea boys' would soon be entering the galley to 'scrounge' hot water to make the ship's gang's tea. The chef was busy making and baking cakes.

Now it must be explained there were thirteen men in an overside gang when it was working under winches. Old Percy, having watched the chef making and baking cakes, had set himself the task of getting thirteen small cakes for the gang to eat during 'Beer Ho'. He thought, however, that after his last encounter with the chef, he wouldn't stand a lot of chance if he asked him for some cakes. He therefore found a piece of strong steel wire on deck that he pushed through one of the port holes in the bulkhead where the baked cakes were being neatly piled up, then he began to have a go at spearing them. He tried several times but each time the cake fell off the end of the wire. The chef was standing at his long table that stretched under the portholes from one end of the galley to the other. He was mixing the ingredients for more cakes, and he had greased the cake tins with butter, not seeming to have noticed Old Percy's efforts with the wire spear. Then finally, no doubt through frustration, the chef got hold of the wire, he shoved three cakes onto it, bent the end of the wire so the cakes would not fall off, and continued with making cakes as though nothing had happened, but Old Percy wasn't amused. He smirked but said nothing. He just stood on the ship's deck beside the open hatch, with the three small cakes hanging on the wire spear, meditating.

The chef came out of his galley and called down the hatch to the 'down-hold foreman':

'Charlie, it's a good job your Procurement Officer is retiring; he's getting too old for his job. He can't cook, and there is one other thing. He'd never get a job on a whaling boat as a harpooner. The silly old sot doesn't know that when you go out to spear something, you need a barb on the end of the spear to stop the catch from getting away. Ha, ha, ha.'

Unfortunately, the chef was more intent on 'extracting the urine' out of Old Percy, than to notice the old man quickly skirt round the outside of the galley, and go in through the opposite door. Then even more quickly, exit and disappear down Number 3 Hatch into the upper 'tween deck, carrying a tray of freshly baked cakes. When the chef re-entered his domain a loud yell went out.

'Jesus Christ! Which one of those thieving 'tea-boys' has pinched my cakes?'

The 'down-hold foremen' looked at Old Percy and said, 'I don't think I should ask the chef to apologise for his slight about your procurement capabilities, do you, Percy?'

The old man just smiled at him and said, 'One cake or two, Charlie?'

TALE 13
Asbestos: Deadly Freights, Lethal Cargoes

Just in case any reader may be unaware of the dangers in handling asbestos, perhaps I should begin this tale by explaining. It is a fibrous hornblende, separated into flexible filaments, and possessing the property of being incombustible. It is, in fact, a dark brown, black or green mineral, a constituent of granite and other rocks of the Devonian period that are made up chiefly of silica, magnesia and lime. Asbestos is an ultra-dangerous mineral that, if inhaled, is lethal to the health of both man and beast. Neither dockworkers, nor any other industrial workers employed in industries that handled or used asbestos before the 1970s, were ever to my personal knowledge warned of its dangers to them, or their family's health and lives. (Included in the Productivity Agreement [Devlin Stage II], page 42, Schedule 8, 1971, it states: 'obnoxious Cargoes-Impersonal issue of Overalls. Employers' will provide overalls on an impersonal basis for the following dirty and obnoxious cargoes: – (b) Wet salted hides and Asbestos.)

To be affected by handling, using, or breathing the fibrils of this natural substance, it could, and too often did, bring about a slow and painful death. Workers in many industries who were ignorant and not made aware of the dangers of being exposed to asbestos in its raw state, especially those people employed in many manufacturing processes for which asbestos was used, worked on or with this deadly substance in their innocence, and died horrific deaths because of it. As did many housewives, who died simply by breathing in the dry asbestos dust before washing clothing impregnated with that deadly material. I must bring to your attention that all raw asbestos was imported by sea from various sources, and was discharged from ships by stevedores or dockers. The bulk of this most dangerous of minerals came from Rhodesia (blue asbestos) in central Africa, and Canada (white asbestos). Those two countries being the major producers and exporters of that lethal, fire resistant natural mineral.

It is obvious, therefore, that dockers and stevedores were in the vanguard of those workers who were obliged to handle asbestos as part of their employment duties. It was a deadly freight, a lethal cargo, to anyone who worked with it. The tonnage 'piecework rate' in 1954 for discharging asbestos was three shillings and five pence per ton, paid between a twelve-handed ship's discharging gang working the cargo 'over-side' into sailing barges, or Thames lighters, when the commodity was imported in hessian sacks. A five pence per ton addition was paid when raw asbestos was imported in paper bags.

Asbestos, when it was being discharged from ships, caused the ship's holds to be filled with its fibrils. It was as though a thick fog had descended over the men working in the holds, particularly when they were in the lower holds. Many of the men, and their wives too, would eventually die from that dreaded lung disease pneumoconiosis, a dreaded disease more commonly known among us semi-literate members of the working classes as asbestosis, or lung cancer.

However, it was unusual in my experience for raw asbestos to be exported. When it was shipped abroad it was generally in a manufactured form, so it therefore came as a complete surprise to me, when I was detailed by the Port Authority dock labour master in the Dock Labour Compound to

report for work on removing freight from railway trucks. Freight that in the event turned out to be cases of raw asbestos.

Now, to handle any export consignment, Port Authority quay gangs were generally made up of eight men (unless they were working with a Stacker Truck, then there would be only three), two men would strike the freight and load it onto wheelbarrows to be pushed into the area allotted for a specific overseas port in a transit shed. There were six cases of asbestos in each railway truck. Each case measured approximately 4 feet by 4 feet by 6 feet, and they weighed about 5 or 6 hundred weights each. I cannot remember now, off hand, how many trucks there were, but it was two complete rail shunts of about forty trucks, something in the region of a hundred tons.

The problem with striking the cases of asbestos was that they were locked together by their wooden battens, that is, the battens of one case being jammed against that of another. This interlocking was due to the trucks having been shunted on the railway line causing them to jamb together. So in order to separate one case from another we had to lever them apart with steel crow bars, shove the blades of a barrow under the bottom case, and drag two cases out of the trucks together onto the raised bank at the rear of the transit shed, before they could be loaded onto wheelbarrows and taken into the transit shed where they were to be stored while awaiting shipment.

As we worked and sweated, asbestos fibrils came out of the packing cases in thick, bluish white powdery clouds. All of us who were working in the cargo striking gang were smothered in a fluffy cocoon of the stuff; the fibrils clung to our sweating bodies and clothes in a thick layer. We all looked as though we were already wrapped in shrouds as surely, and unbeknown to any of us, some of our number would be in the course of time, sooner in a number of cases instead of later, because of our exposure to the raw asbestos fibrils.

We had began work on striking the cases of asbestos just after 8.00 a.m., and we worked on till 9.30 a.m., when a Port Authority Mobile Canteen (from which the tea lady sold mugs of tea, coffee, and sandwiches, rolls and cakes), drew up on the quayside. And although we were choking from the asbestos dust, and thirsty (there were no facilities close by in those days to wash one's hands or get a drink; not even a drink of water), we waited patiently in a queue for the ship's crane drivers to get their tea first. (It was a golden rule in the docks that crane drivers could 'jump the Mobile Canteen queue' because work on ships always had priority over every other job, and the work couldn't proceed without them.) Then each of us ordered two mugs of tea.

Jean, the 'Tea Lady', as the canteen girls who drove the mobile tea vans were affectionately known, looked us up and down then said, 'Who's your tailor? I'd like to buy my husband a suit like that. I bet they're nice and warm.' Then, more as an afterthought she said, 'where have you lot managed to escape from, dressed in those silk worm cocoons?'

'Those sodden railway trucks on the back door,' was our unified reply.

'Haven't you been supplied with overalls? You won't be allowed in the canteen at lunchtime dressed like that, you know. I'd be asking for dirty money for doing a job like that, and some overalls, if I was any one of you.'

'Yes you're right, Jean. We shall. We had never given it a thought,' was our unilateral reply.

After we had drunk our tea and eaten our food, which by this time had more than a few fibrils floating on the tea and covering the food, we made our way en-block to the Port Authority's shed foreman's office to confront him. But before we had a chance to open our mouths he said, 'what do you lot want? Why aren't you back at work? You are supposed to be having a tea break, not a public holiday.'

'Because,' I replied, 'look at the state of us. We want dirty money for this job.'

A British Railway (BR) vehicle and passenger ferry at Tilbury Riverside Passenger Terminal, *c.* 1940s.

Above: The British Rail (BR) steam ferry *Tessa* waiting to 'coal-up', *c.* 1950s.

Right: British Rail (BR) freight train waiting in railway sidings for its export freight to be struck off the railway wagons into a warehouse ready for shipment, the Royal Albert Docks, *c.* 1960s.

The foreman's eyes almost popped out of his head with indignation. 'Dirty money!' he echoed. 'Whatever for? You've got a good job there. There's 60 tons of asbestos in the first rail shunt, and another 40 tons in rail trucks waiting up the railway track. You're losing time. Get back to work,' he ordered.

He then made as if to slam the office door in our faces, but one of my work mates put his boot against the jamb. 'We're not going back to work till we have seen a traffic officer about being paid dirty money,' I said, and all eight of us sat down on some pallet boards outside his office window. However, it was some time before a Port Authority traffic officer arrived on the scene. He had had to walk about 300 yards from his office to where we were, but it must have taken him at least half an hour to get where we were waiting for him by the shed foreman's office door.

The traffic officer (a Port Authority overseer) opened his dialogue with the usual verbal claptrap of, 'what's your problem, and why aren't you working. Are you on strike?' he asked in that usual supercilious tone of voice most people who have been given certain powers adopt when talking to work people on the shop floor who are trying to air a grievance.

'What's your problem?' Is generally about as much formal conversation one can get out of them, because they have no intention of discussing your work problems with you. They have a set procedure they follow, and they have no intention of allowing anyone else to be a part of it, certainly not those workers who are directly affected by it.

'We're asking for dirty money for this job, look at the state of us,' my mate nervously blurted out.

The traffic officer looked at us and laughed, 'Dirty money! You lot should be paying the Authority for clean money. I've never seen any of you look so clean before now. So don't be silly. You're losing money. You've got a good piecework job (Crated or cases asbestos was classed as general cargo, paid as dead weight tonnage at two shillings and six pence per ton, or five pence per ton per man), so get back to work. I've sent for a Trade Union Officer to discuss the matter on your behalf.'

We knew immediately our cause was lost before the Trade Union Officer turned up, because they had obviously been discussing our case over the telephone, so we sat down again and waited for confirmation on what we had already deduced. When he arrived on the scene the T.U. officer turned out to be a port authority 'perm shop steward', not a T.U. officer at all. The 'perm' immediately got out of his pocket a Port of London, Ocean Trades, Piece-Work Rates Price Book that quoted the ship-discharging rate for handling asbestos, thereby confirming our suspicions that there had been a pre-empted agreement between them. However, we were not going to be put down by that pre-arranged decision made on our behalf over a telephone.

'That book of rules don't apply to us,' we told him. 'We're working for the Port Authority on a railway freight striking operation, not on a ship discharging job.'

'Then the Port Authority agreed rates apply,' he said, 'half a crown per ton with no contingency payment.'

'All right!' we told him, 'we'll finish the job, but be sure this case will be taken up at the next T.U. Branch Meeting.'

It was, but nothing was done about it till long after the dangers of asbestos first became publicly known. Then the port employers began to issue face masks that were both flimsy and useless, because the mask filters soon became clogged with asbestos fibrils, and the masks had to be removed to allow the users to breathe and work. That was a very good 'legal let out' for Insurance Companies in claims brought by a litigant for compensation at the onset of the industrial disease known as asbestosis. When he/she is in the High Courts of Injustice, the highly paid imminent Q.C. acting for some Insurance Company on behalf of an employer, or vice versa, begins his/her questioning, while hiding behind a

disarming broad smile, he/she asks, 'Now Mr or Mrs X. Have you at any time worked in previous employments where you have had to work with asbestos?'

'No, sir.'

Then the tone changes sharply with, 'do not address your replies to me. Address your replies to his lordship. Now then, did your employer issue you with a face mask as a protection against breathing in asbestos fibrils while you were working, and did you remove that mask while working with asbestos?'

'Yes, but I!'

'No but I please. Just answer the question. Yes or no!'

'Yes.'

You know the rest: 'Me Lo'd. This man/woman is obviously at least partly responsible, if not totally responsible for the condition from which he/she is suffering. You have heard from his/her own evidence that he/she was issued with a protective face mask by his/her employer, and removed it on his/her own volition, and without authority, whilst he/she was employed on working with asbestos. I therefore ask Your Lordship to give due cognizance to that fact, when considering the evidence and calculating, *if any*, what compensation there should be under this claim,' or words to that effect.

The legal decisions that are finally made by judges in such cases, more often than not, hardly matter to the litigants anyway, as most of them would have slowly suffocated to death before their cases are concluded. As is usual in all such cases, years are allowed to roll by before compensation claims are brought before the courts, and are finally settled, and monies may be paid out to the victims or their dependents. That by itself is a travesty of justice. However, I must admit I have never heard of any legal representative of litigants ever asking for a time limit to be placed on settlements of compensation claims on their client's behalf. Why is this I wonder?

Conclusive facts

Not only did dock workers die from handling asbestos, but so too did thousands of workers, men and women, in manufacturing industries, and wives too who shook and washed dirty asbestos impregnated overalls. The full tally of victims who died from asbestosis, and other forms of industrial diseases attributed to pneumoconiosis for that matter, will never be known. This is because in many cases the cause of death was/is deliberately put down to some other cause. I know of a case where the asbestosis victim's death was certified by his General Practitioner (GP), as 'a chest infection.' This was even though the GP had referred the man to a consultant chest specialist, and knew the man had been under treatment for the asbestos disease at his local hospital, and Saint Thomas's hospital, London, for over a year. I had that case reported to a coroner's office. The coroner ordered that an autopsy should be carried out. It was, and a correctly certified death certificate was issued that enabled the widow to claim compensation for the loss of her husband. I first became aware of the dangers of asbestos when a stevedore working in the Millwall docks reported to the London liaison committee that his sister-in-law had died of the disease after years of washing his brothers impregnated overalls, and his brother had lost one of his eyes. Finally, the insurers at Lloyds of London were almost brought to their financial knees by claims from American victims of that dreaded killing disease. Asbestos: those deadly freights, those lethal cargoes.

TALE 14
Big Dave and Little Fred's Lighter

Big Dave was the 'top-hand' to a ship's gang that was working in the 'after main hold', which for the uninitiated is Number 3 cargo hold directly behind a merchant ship's bridge. The ship in question was a vessel of the West African Conference Line, out of Liverpool. It was berthed in Tilbury Docks, close to the old dock entrance at the eastern end of the docks complex. The dockers discharging the vessel were working 'over-side' into lighters (that's on the dock fairway side of the ship, away from the quay), discharging groundnuts, imports from the now infamous 'Tanganyika Groundnut Scheme'. A scheme that was set up in Tanganyika, Africa, by the British post-war Labour government in its endeavour to overcome a shortage of vegetable oil after the Second World War. Groundnuts, on having been discharged from a ship, were to be taken by Thames lighters or sailing barges to a processing factory, where they would be crushed for their rich mineral oil content.

The oil extraction processing operation would be carried out at Jerkins factory, further up the river Thames at Purfleet, a destination set about 20 miles down the river from East London, and 10 miles upriver from Tilbury docks. The Jerkins factory was situated on the Northern bank of the Thames, and craft that had been loaded with groundnuts in Tilbury docks were towed by river tugs to their discharge wharf, close by the Jerkins factory site.

It was, therefore, because of the importance attached to any sort of nut, and the nutritious value in its oil, a great deal of significance was placed upon these shipments. For the reader's information and edification I hope I do not appear to be condescending in supplying the following information. Groundnut oil is not only edible, but is used for a variety of purposes, for example in the manufacture of margarine; as a cooking oil; in the manufacture of washing powders and soap; as a fuel for running engines; and even in the manufacture of high explosives. In addition, residue from the pressing process of groundnuts is turned into cubes for cattle feed, or for use as an agricultural fertiliser. Nothing gets wasted in the manufacturing process, absolutely nothing.

The cargo-carrying vessel Dave and his ship's gang were working on was in its second day of discharge. So it was still relatively low down in the water, showing about 20 feet of freeboard above its Plimsoll line. Plimsoll lines are those marks painted on ship's sides, along the deep water line, which are meant to show the depth to which the ship is allowed to be laden either in fresh, or in salt water. It was a system devised by Samuel Plimsoll (1824-1898), an English social reformer, who also secured the passing of the Merchant Shipping Act of 1876. Legislation that was put in the Statute Books, specifically designed to prevent the overloading of ships. Another reason for the introduction of the Plimsoll line was to deter some unscrupulous ship owners, who sent overloaded ships to sea with the intention to lose the vessel so as to claim its marine loss insurance, and other such abuses used by the ship owners of the merchant navy. Samuel Plimsoll's name has been given to the circle with the horizontal lines through the centre, now placed by the authority of the Board of Trade on the sides of every cargo carrying merchant vessel, indicating its deep water line.

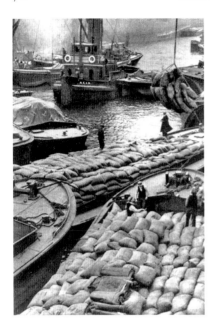

Discharging groundnuts (peanuts) over-side (dockside), *c.* 1960s.

On the occasion of this tale, the ship's taffrail had been removed to allow free and safe passage for the sets of discharged groundnuts to be swung out of the ship's hold and across the deck, before being lowered and stowed into a lighter. The gang were working with electric winches under a union purchase. (A union purchase is two winches, one on either side of a ship, that have revolving cast iron drums, both of which have a steel wire bolted to them. The steel wires run from the winch drums, through a heel block on the ship's bulkhead, up through steel safety guards beneath the derricks, through a derrick's head revolving head-block, then down to the ship's deck where the spliced ends of the 'running wires' are attached to a union purchase by shackles, to a swivel hook. This contraption is known among seamen and the dock working fraternity as 'a union purchase'.)

The method of discharging bag-work varied according to each commodity. For the discharge of wheat flour for example, Tilbury dockers would have used flour nets. For groundnut discharge, rope snotters were used. Snotters are single ropes with a spliced eye on either end. Each snotter held nine bags of groundnuts, and each bag weighed 140 pounds. So, each single set discharged from a ship weighed over eleven hundredweight when nine bags of groundnuts had been put in a snotter. When two sets of groundnuts were sent up from the hold together they weighed over twenty-two hundredweight. The method of securing sets of groundnuts for discharge into lighters or barges was simple. One eye of a snotter was threaded through its other eye, which was then attached to a hook on the union purchase before being hoisted.

Before ship's gangs began using single snotters to discharge bag work from ships, spliced ropes had been used. The single ropes held twelve bags, weighing in all a total of fifteen hundredweight. As the gangs were paid on a tonnage piecework basis (two shillings and ten pence per ton, thirty four old pence among a twelve handed gang = 1 new penny per man per ton in decimal coinage) they devised the new method to increase their wage incomes. At first, employers bulked at the idea, saying the method was unsafe. But they quickly realised their ships were being discharged several days faster than when ropes were used. So, they very soon reneged on their opposition to the new practice, and surreptitiously got over the safety angle by simply having snotters made using thicker rope.

Now I have to explain, when a ship was working cargo under derricks, three of the ship's gang worked on deck. They were a 'top-hand' (or hatchway-man) and two winch drivers. The 'top-hand' gave various hand signals to the winch drivers (it was a deaf sign language of sorts) to raise or lower the union purchase. When the 'top-hand' wanted his colleagues to stop the winches from working, he would simply cross his arms half way between his elbows and his hands. The drivers were then supposed to stop their winches and hold the set wherever the 'top-hand' had ordered. Unfortunately, there are always exceptions to any golden rule, and this was to be one of them.

On the day of this tale Dave, who was acting as the gangs 'top-hand', signalled his two winch drivers to hold a set of groundnuts half way across the ship's deck, between the side of the hatch combing and the ship's side, about 3 feet above the deck. He should have known better and landed the set on the deck for safety, because a lighter-man was floating an empty lighter under the over-side derrick. Dave should have realised he had to remove the lighter's hatch beam, once the lighter-man had taken off the lighter's hatch covers.

However, instead of carrying out what was the usual procedure and landing the next set for discharge on deck, Big Dave's 25 stone, huge body was poised close to the edge of the deck as he looked over the ship's side watching his friend Little Fred drift a lighter alongside the vessel, then bring it to rest under the 'over-side' derrick head. The lighter's beams and hatches were still in place as Little Fred began to make the barge fast against the ship's side.

It was then, without been given a signal, that the over-side winch driver hoisted the set of groundnuts. As it came off the deck it caught Dave full on the seat of his trousers, and he disappeared over the ship's side to the sound of an almighty crash. Everyone on deck who heard the noise rushed to the ship's side just in time to see Dave picking himself out of the splintered wreckage of what had once been the lighters after beam and hatch covers. Fortunately Dave was uninjured.

Little Fred, on the other-hand, stood on his lighter's prow, staring for some seconds in utter astonishment at the tangled mess, with his mouth agape and eyes staring in disbelief, before he opened up with verbosity, though not necessarily with veracity, in a tirade of verbal abuse towards his friend.

'Why!' he blurted out, 'you blundering great jackass! You monolithic moron! You idiotic stupid oath! You despicable renegade! You oversized three in one human colossus with a brain the size of a dinosaur's! Look what you've done to my lighter's beam and hatch covers! How do you think, if you can, with that minuscule brain of yours, I'm going to be able to cover this lighter up tonight when you lot have finished loading it? How am I going to explain this mess to my Governor?' By the time Little Fred had finished his verbal tirade, Big Dave had brushed himself down and climbed out over the beam and hatch covers wreckage, onto the lighters prow, where he stood towering over Little Fred as a shire horse would tower over a Shetland pony.

Then he said: 'With the way those two organs called lips that form your big mouth have been flapping about, tiny man, I think you may easily be able to cover this craft over with them. Now get yourself down there,' Dave pointed at the debris in the lighters bay, 'and clear that mess up, or float the lighter away. We're waiting to get back to work. We're not like you lot,' he said referring to lighter-men in general. 'We don't spend our lives cruising up and down the Thames, or gliding about the docks all day on the deck of a lighter, sunning ourselves like some of those under graduates at Cambridge University do, who go swanning about on the river Camb. We have to work for our corn, we're piece-workers, or don't you know that you mutton headed midget.'

'Pieceworkers,' Fred moaned, 'by the look of my lighter's beam and hatches, it looks more like you're bits and pieces workers to me. It's just another damn fine mess you gormless oversized idiot has got me into. What am I going to tell my Governor when I telephone in to him for tomorrow's orders?'

'You'll just have to break with tradition and tell him the truth for a change,' said big Dave.

'And what is the truth?' moaned Little Fred.

'You'll just have to tell him an old friend dropped in on you.'

Although Big Dave was acrimonious on the subject of his free-fall into Little Fred's lighter, he did acknowledge that although Fred grumbled, it wasn't without his having reasonable and just cause, despite Dave referring to his bosom pal of yester-year as, 'That loud mouthed, bumptious little toady.' Plus a few other non-essential invectives that I prefer not to include in this tale. That being on my account that the editor may, for the sake of any delicately mentally Christian minded soul, decide it would be better to censor them.

TALE 15

Harry and the Flour Nets Saga

They were, or to be more explicit we were, a motley dressed gang of young men. All of whom (with one exception) had recently been demobilised after having completed their two plus years of compulsory National Service in Her Majesty's Armed Forces, at the behest of Her Majesty's government. It was a duty that was required of all young men by the State, supposedly for and in the 'Defence of Her Majesty's Realm'. However, in our humble and perhaps misguided opinions that was a debatable argument, for it was to our way of thinking a cheap method (similar to the naval press gangs of yester-year) of acquiring under paid cannon fodder for military purposes.

All of them, without exception, had been 'called up' (conscripted) at the age of eighteen years, not having been able to give a good reason for a deferment from the clutches of the military. Now all of them were in their early twenties, they were as tough as old boots and fighting fit. However, two years of 'square bashing' and military discipline imposed on them by 'Regular Army Sergeants'; saluting conscripted ex-public schoolboy officers; and in many cases seeing military action in war zones, had taken a lot from these men. These experiences had built into their young minds a psychological pattern of despising anything, and anyone, who had a pretence to authority over them.

Most of them had been through what is colloquially known as 'the hoop', during service in the jungle fighting in Malaya; on desert patrols in the Suez Canal Zone of Egypt; in the towns and countryside of Cyprus; or for months being frozen cold, or fried alive in trenches on Korean Hills. Although at least those experiences had given them an insight into what their grandfathers, fathers and brothers had been through, and endured during the South African, First and Second World Wars. What is more their 'conscripted military service' experiences had also turned them into an assortment of anti-authority, anti-establishment, pro-anti everything else rebels.

Most of them had grown their hair down to their shoulders, and sported a growth of unsightly whiskers. This was without doubt to spite those army and air force sergeants, and naval petty officers, who were constantly ordering them to, 'Get your bloody hair cut, you 'orrible little man, or If you carry on marchin' like that, I'll bloody well get the lot of you transferred into the Woman's Royal Army Corps.' However, as most of the lads were aware that was a promise the rotten sots never would keep.

It was because of their belligerent and anti-authority attitude, that none of the ship workers in the docks ever wanted to employ them. They were, in fact, *persona non gratae*, and so it was that those 'reluctant heroes' of post war skirmishes with the Queen's enemies abroad were constantly left in the Dock Labour Compounds to await 'allocation' to a quay or ship-working operation, under the 'continuity rules', which bound them to an allocated job till it was concluded. This also meant, of course, they were among the lowest paid men in the docks, specifically because 'allocated jobs' were generally the dross of all employment within the port transport industry; jobs that none of the other older and wiser dock workers wanted to do.

What is more, and it is a fact, they all wore togs to work that they had brought home with them after they had been demobilised. Togs that had been their uniforms in various military units in which they

had served, minus their unit's military flashes, or regimental names, which had been surreptitiously removed. Harry S., for example, had served with the Rifle Brigade, therefore, he and the other ex-army lads were kitted out in Khaki. Eric C. had been with the Royal Navy, and although he had no bell bottom trousers, everything else he wore was in Navy Blue. Charlie G. was a 'down-hold' foreman who was referred to by his younger workmates as a relic. For he had served during the Second World War. Charlie G. wore a faded light blue RAF battle dress. Though it was known he had been transferred into the army a few months before the D-Day landings. If he was ever asked from where he had obtained his RAF uniform, he would run a hand through his hair and reply, 'One just doesn't wish to shoot a line, old boy, when one is asked such a question, does one.' (However, it was quite often hinted by a number of dockers, who had known him when he was in the services, that he most probably snatched the uniform off 'somebody or other'.)

The background of the diverse types of characters who left military service and became employed in the port transport industry, and of their psychological attitude towards employers who replaced military authority with a civilian industrial authority that could not be reinforced by military type discipline, gave many men a type of mental freedom that could only be overcome in a capitalist society, by the need of money for their ultimate survival. These few facts should give the reader an insight into the deep resentment felt by many of the young trained fighting men that were employed in the docks, who were forced into military service shortly after the Second World War had ended. It has to be emphasised that most of the older men employed in the docks were ex-service men as well, who were themselves survivors of conflicts reaching back as far as the Boer War. Yet there was more war service to come for some of them. The Malayan Emergency and the Korean War had ended. The Egyptian War in 1956 over the nationalisation of the Suez Canal by Colonel Abdel Nasser (1918-70), and the Cyprian conflicts, brought about by the demand of Archbishop Makarios III (1913-77) to unite the island with Greece were soon to begin. So, many of them were recalled into the armed services under the Z Reserve Scheme, to go once again into the armed services of Her Majesty.

The clothes these former 'reluctant heroes' wore to work were due, in no small measure, to the miserly pay they had received from H.M. Government during their compulsory military service. Yes, for having to forfeit years of their young lives that had spoiled any chance they may have had of training for a trade (professional training was not available in those days to the likes of *them*, that option never entered the social equation as far as *they* were concerned). Even then, not many of them had much chance of such opportunities. All of them had been pupils at Church Schools, where school masters appeared to be of the opinion that whatever little knowledge they had to impart to their pupils, had to be beaten into their charges through their rectums with a cane, and not by educational stimulation of the mind through intelligent teaching methods or tutorials. They had had to give up everything for their King/Queen and country. Something that is more than their country, if not their King/Queen, was ever prepared to do for them.

However, to progress with this tale I have to explain, we had all been in the National Dock Labour Compound for the 12.45 p.m. 'Labour Call On'. George R., a ship worker for one of the many stevedoring labour contractors, was on the 'Call Stand' waiting to recruit, or indent through the Dock Labour Board, for a pressed ship's gang. He had 'picked up his crane driver/winch driver', and Charlie G. his 'down-hold foremen', four barge hands and a pro-rata man to act as a capstan operator. He now required a full complement of 'down holders'. He was stood on the 'Call Stand' with a broad smirk on his face, knowing full well some of us rebels would soon be at his unforgiving mercy. At some time or other all of us had crossed George's path. Now we could see from his facial expression, he thought he was going to have all of us by the proverbial testicles.

'Sod him. We'll most likely be allocated to him anyway. So why bother to volunteer for his crap job,' said Harry S.

'What cargo has his ship got?' Eric C. asked.

'It's a loading boat, I think!' one of the other lads replied.

'Loading what?' said Harry.

'We're just about to find out,' Eric said. 'Here comes the voice of the Invisible Man,' and with that last remark allocation orders began to come over the Tannoy intercom system from within the Dock Labour Board Office, or to be more precise, the port employers Registered Dock Workers employment agency, 'All 'A' Books in.' The Dock Labour Boards allocation of our bodies as wage slaves to George R. was about to begin.

Within five minutes we knew who the unlucky six men were that had been allocated to George R. as a ship's loading gang. They were to be: 'Harry S., Eric C., Henry B., Jack H., Ron S., and Leslie T.' The voice of the Invisible Man boomed out over the Tannoy system:

'Join the SS (it had an unpronounceable Greek name) at 26 berth.' We, the unlucky six, left the Dock Labour Compound together, and made our way to our allocated ship. Well, it had been a ship long, long ago, but a couple of World Wars and years of tramping the seven seas had taken its toll. It was now a rust bucket well past its sell by date, even for a ship-breakers yard. It was a floating abomination owned by a Greek shipping company. A tramp steamer in every sense of the word, sent to pick up odd consignments of cargo for a Conference Line working on a Charter Party Contract, so as to convey small shipments of Conference Line cargo to ports where vessels on liner schedules never operated.

When we of the 'pressed gang' arrived at 26 berth, we were allocated to Number 1 Hatch, where we were to be working under a single derrick with a single steam winch. The pro-rata deckhand, who had been 'picked up' by George R. in the Dock Labour Compound, had the job of using a rope's end on the outer winch drum to haul the single derrick back over the ship's hold, when a set of cargo was ready for loading. 'Dead men' (drums filled with concrete) were to be used to pull the derrick back over the barge after a set of cargo had been landed in the ship's hold, and the loading tackle had been hoisted up to deck level. None of us had anticipated we would be loading hundredweight bags of cement. When we found this out we made a detour to the Port Authority stores and got the store keeper to give us some mutton cloths to wrap round our heads, and bands for our wrists, to stop the hot cement dust from chafing through the skin on our wrists and drawing blood.

When we got back to the ship Harry and I changed over to become barge hands, because two of the other barge hands with us were more experienced 'down holders'. With a gang of 'pressed (unimpressed) men' working under a single derrick, it was agreed that Charlie G. was going to require all the experienced help he could get, stowing cement in the dark depths of the ship's lower hold.

Perhaps I should explain here that in those days shortly after the Second World War, the practice when loading cement onto ships was to use large heavy wooden loading boards, backed with steel crossbars and lifting wires. Two-and-a-half tons of cement in hundredweight paper sacks was put onto a loading board, which was then winched or crane lifted into a ship, and stowed wherever it was required in the hold. This method had been used since time immemorial, and nobody had ever thought to alter it. That was until now, when the system was about to be changed forever, by a scruffy ex-soldier who looked more like a pirate than a former conscripted rifleman of his Britannic Majesty's Rifle Brigade.

We had begun work by loading the first cement board with fifty-one hundredweight bags of cement. We'd put the four purchase hooks that were attached to the union purchase, one on each corner of the cargo board, and signalled to the 'top-hand' to take the set aboard the ship, but nothing happened. The 'top-hand' called down to us from the ship's deck saying the winch wouldn't lift the set, and we would have to take half a ton of cement off the board. We did that, but the winch would still not lift the set. He called down again and said to take another half ton off the board. We did that, and the sodden winch lifted the set about a foot off the barge ceiling, then ran out of steam, and dropped the set back down again with a crash, that made the lighter bounce up and down causing a small tidal wave to ripple right away across the dock.

'Are we supposed to be loading that sodden ship or this damn barge?' said Harry.

'Don't blame me,' said the 'top-hand', 'if the bloody winch won't lift it.'

'What's the lifting weight stamped on that winch, and painted on the derrick?' Harry called up to the 'top-hand'.

'Three tons,' was the reply.

'We're down to thirty hundredweight of cement now, and the cargo board and purchase tackle can't weigh more than five hundredweight. We've been here the best part of an hour already, and we've not got a bag of cement aboard the bloody ship yet. Sod it, I'm going the see George R. to ask him for a price for doing this job.'

Harry clambered out of the barge, scrambled up the rope ladder onto the ship's deck and made his way aft to find the ship worker. He soon returned with George R. and they looked down into the barge where the set of cement was still virtually stuck by its own weight to the barge ceiling.

'There's only thirty hundredweight on the cement board, George. Now *you* tell the 'top-hand' to raise it,' Harry said.

George gave the 'top-hand' a nod. The 'top-hand' gave the winch driver the hoist signal. The winch, which was steam powered, hissed, coughed, spluttered, puffed, gasped and farted, but was unable to lift its load of cement.

'You'll have to take some off the board,' said George.

'We've already taken a ton off the cement board,' replied Harry. 'We're supposed to be loading this rust bucket of a ship, not the barge. We want a price for this job.'

George laughed. He was enjoying this moment. 'This ship's not due to leave port for a couple of days,' he said. 'The Governor won't sanction a price for a 150 tons of cement. It's only half a day's work for a regular ship's gang. No, you're not on for a price job,' and without any more ado he turned his back on us, and walked off along the ship's deck with a supercilious grin on his fat face.

'The stingy old bastard,' said Harry. 'Well, he's not making a fool of me. I know what we'll do. You take some of that cement off the board, and keep that winch moving. I'll be back as soon as I can. We'll show that old sot what we can do when we put our minds to the task.'

Harry had, in the meantime, come back down into the barge. But as soon as George R. had disappeared along the ship's deck he climbed out of the lighter, scrambled up the rope ladder onto the deck, and disappeared down the ship's gangway onto the quay. We started to send a ton of cement at the time on each cargo board, which meant a job that should have taken half a day to complete, could now run into a full day's work operation. George R. came forward along the ship's deck several times to gloat at us over the ship's side, before going aft to see how his 'blue-eyed boys' at the main forward hatch (No. 2) and after main (No. 3) hatch were getting on with their cement loading operations. They were using the same type of cement boards as we were, but they had union purchases that had five ton lifting capacity winches. They would achieve their piecework targets of 250 tons a day without too much trouble. But George R. was about to learn a lesson the whole of the port transport industry would ultimately benefit by, that is, all except its inventor, Harry S.

After being away for about half an hour, Harry S. returned. He brought with him five rope and canvas nets on a wheel-barrow. These nets, ropes with canvas stitched between them, were at that time used exclusively for the discharging of bags of flour. He carried them up the ship's gangway, threw them down one by one into the lighter from the ship's deck, then he clambered down the rope ladder into the lighter after them.

One of the older dockers, imbued in using the heavy wooden cement boards asked him, 'What are we supposed to do with these damn things?'

'I'll show you,' said Harry, and he began to put bags of cement in the nets. 'We should try putting twenty-five bags in the nets at first, that's five along and five high,' then he said, 'that's it,' and to the 'top-hand', 'take it up.'

'What's that supposed to be?' the 'top-hand' said. 'Not bloody likely, it looks damn dangerous to me.'

'It looks what!' said Harry, and he was off out of the lighter again. He scrambled up the rope ladder onto the deck, where he signalled to the winch driver to take the weight off of the set and bring it up level with the deck, then signalled to the winch drum ropes end operator to bring the set over the hold, then for the winch driver to lower the set down to the men waiting for it in the lower hold.

'What's this?' The voice of Charlie G. the 'down-hold foreman' called up from out of the dark, dingy depths, far below.

'It's a new system we're trying Charlie,' said Harry. 'Give it a chance.'

After a short pause Charlie G. shouted. 'This is a bloody sight easier Harry, than lugging those damn cement boards about. Can't you get a few more bags in each set?'

'Right!' replied Harry, 'We will if the winch will lift them. We'll try twenty-eight bags,' and he swung himself back over the ship's side onto the rope ladder and climbed back down into the lighter. 'It works all right. Charlie says put more bags in each set. Let's try seven high and four wide, that's twenty-eight bags.' We did. It worked.

By the time we had got ourselves organised, it was past three o'clock in the afternoon. Harry said, 'Do you know, if we keep up a regular twenty-eight bags in each set, we will only have to do twenty-seven sets an hour to finish this 150 tons by seven o'clock tonight.'

'Christ,' replied one of the other barge hands, 'I've never worked so easy on a cement job. No lugging those cement boards about. This job's a bloody doodle now, compared to what it was, and what's more we'll make it pay this afternoon if we finish the job.'

It was exactly 6.00 p.m. when George R. appeared on deck. He looked down the hold where the gang was sitting talking. Then he crossed the deck and looked down into the barge where we barge hands were sitting talking. But to his great surprise there was a last set of cement left wrapped up in a cement net, ready to be hoisted onto the ship as soon as the hands of our watches went past 6.00 p.m. so we could claim an extra hours overtime payment.

Then he said, 'what have you shower of villains been up to? How have you managed to get this job done so quickly?'

'It's a new method of working we've devised. It's all thanks to you, you stingy old bastard,' I called up to him. 'You thought you'd stitched us up this afternoon, didn't you? But we can thank Harry S. you didn't have the last laugh on us, you cunning conniving old sot.' Then as an afterthought I said, 'by the way George. How are your blue-eyed boys getting on at Number 2 and 3 holds?'

It was a comment that brought a good deal of laughter from all the members of our gang. George R.'s only comment as he walked back aft along the ship's deck was, 'Whoever would have thought it!'

The Sequel to this Story

No one ever thanked Harry S. for introducing the new method of loading cement. However, the consequence of the introduction of 'flour nets' as cement nets increased cement loading from approximately 260 tons per ten-hour day using the heavy cement boards, to 500 tons over an eight-hour day. The last two hours of each working day (from 5.00 p.m. till 7.00 p.m.) being given over to working general cargo on Captain Magnus Work's orders. This was because his dockers were exhausting themselves each day in their endeavours to continually exceed previous set tonnage targets.

Finally, you may be interested to learn what happened to Harry S. Well, he was dismissed from the docks for a minor misdemeanour, and never returned to work in the Port Transport Industry again. Now what do you think about that as a reward for his ingenuity?

TALE 16
My Doctor Became a Docker for a Day

There is absolutely no doubt about it at all, to my mind he is an eccentric. I don't think he's actually mad, but he's certainly done some quite odd things in his lifetime, for a doctor that is. For example he jumped out of an aeroplane (with a parachute of course) for a dare, and he did a Bungee Jump while visiting New Zealand, for some unexplained reason. On another occasion he slithered across the mud flats at Cliffe Creek, just below Cliff Fort by the river Thames (with his dog), to collect samples of mud in a plastic drain pipe, which he kept in his mother's deep freezer. (The mud was for a research project he was carrying out for the Open University.)

He has also crossed the Atlantic Ocean under sail (that's where he had the best bit of luck in his life, for he met and later married Celia, who has done a great job keeping him under some semblance of control). He has waded up to his neck in foul smelling mud and water, on conservation exercises, while clearing rubbish from the Gravesend to Strood canal at Higham, Kent. He has also sweated with other members of The Dickens' Country Protection Society (an organisation that he himself had set up to protect the Kent Countryside, and the North Kent Marshes, from destruction by developers and their ilk). He organised sessions for this group, clearing rubbish round the villages, churchyards and country lanes of Dickens' Country, off the North Kent Marshes. He has helped too in clearing of the river's foreshore and marsh salting (a tidal area of the river between low and high tide) along the Thames riverside, from Higham Bight to Egypt Bay, removing and burning flotsam from London and the down-river towns, and jetsam discarded from ships using the docks and wharves along the river's banks, and from lighters discharging London garbage at Mucking Flats, off East Tilbury, on the North Bank of the Thames in Essex.

Yes, in all truth, Doctor Colin Smith is one of those exceptionally extraordinary people, who don't give a single toss for convention, political correctness, or any of those other mind bending formulas designed as propaganda gimmickry by psychologists and psychoanalysts. Principles created at the behest of high ranking civil servants acting on behalf of consecutive governments that they advise, to be foisted on gullible citizens by mass media propaganda, in order to coerce them into social and economic conformity, but not he. He decides for himself what is right, only after he has examined the evidence, questioned the answers based on the motive, and then re-examined the facts before determining what he considers to be the truth, or the fiction, relating to the matter in question.

Doctor Smith had trained at Guy's Hospital, London. He'd been an Orthopaedic House Surgeon at Whipp's Cross Hospital, Leytonstone. Then instead of taking the easy option of doing his National Service, or going into general medical practice in Britain, he opted to go to Basutoland as a Government Medical Officer. In my estimation, he is a bloody good bloke. I suppose the 'chaps' from his Prep and Public School and University days would have referred to him as a 'top hole fellow' or 'jolly good fellow' or some such thing. Whatever he was called, he was a very unusual doctor in his deeds, his words, and his actions.

I first met my eccentric friend Colin Smith (I don't suppose he will mind if I refer to him as a friend, after all dockers and doctors are not generally known to socialise) when he joined the General Medical Practice near my home in Wainscott, Rochester, Kent. I often had to consult him at his surgery about treatment to injuries I had received while working in the docks and he, being an inquisitive nosy sod, often asked me questions about different practices that were carried out in the London Docklands. He was especially interested with regard to the loading and discharging of ships, labour relations, and strikes that were continuously reported by the mass media about the docking industry. He was surprised to learn that Registered Dock Workers were 'picked up' (hired from the Dock Labour Boards in Dock Labour Compounds, and hired out to stevedoring contractors as casual workers). They were not employees of those companies, so they could never be classified as being on strike if they chose to withhold their labour, simply because they were not employees of shipping companies, but casually hired workers. 'What,' he would ask, 'was the difference between dockers and stevedores? What was the function of a Docks Liaison Committee? Who is this fellow they call Jack Dash?'

Doctor Colin Smith wasn't entirely ignorant about ships. He had experienced sailing about the Atlantic on an old pilot cutter named *Theodora,* and had worked on a banana boat as a supernumerary Medical Officer, sailing on the *Frubel Clementina* out of Antwerp to the Belgian Congo. However, as was his habit, he was always very curious and questioning as to the whys and wherefores of any problem. Then one day, out of the blue, he asked me if he could come to the docks to look around. I suppose I should not have been too surprised by his request, after all, he was a bit eccentric. He had to be to want to wander round the docks. However, I thought it could do no harm to humour him, and I said I would make enquiries, and get a Port Authority Visitors Pass to show him round – which I did.

Anyway, that's how doctor Colin Smith came to make a visit to Tilbury Docks, to be inducted and educated in the practices and art of docking, and where he met some of the registered men who made up the dock's work force. Men whose articulation in speech and skills in their jobs, rather surprised him. However, I suppose he, like so many other people, had become used to accepting the adverse propaganda dished out by mass media organisations against coal miners, dockers, and other wealth producing workers. Groups who were generally referred to as manual labourers by employers (and ignorant members of the general public who had not one iota of the knowledge and skills required in carrying out the functions such workers perform), and as blue collar workers by academics and personnel officers. So on the appointed day of his docks visit I picked him up outside his house on the Gravesend Road. A rather large house that was next door to his favourite pub, 'The Sir John Falstaff,' and took him across the river Thames on one of the Gravesend to Tilbury steam ferry boats. From here we walked up the passenger ramp, through the British

A Blue Star liner off Tilbury Docks new entrance, *c.* 1960s.

Tilbury Docks showing ships berthed in the Northern and Southern Docks and the Old Docks entrance built in the 1880s, *c.* 1960s.

Discharging an elephant imported from India onto the quay, *c.* 1960s.

Rail Riverside Terminal into the docks. It was to be an educational exercise and tour he would remember and cherish for the rest of his life.

I began Colin Smith's tour by showing him round the transit sheds, and explained how cargo was received in, and delivered from the docks. Then we made our way to the Stothard and Pitt quay cranes. His first question was, 'How do these things work?' I switched on the electric power at the bottom of a crane's superstructure, and we climbed up the four 20 feet vertical ladders into the crane cabin of a 90 feet jibed mechanical monster. I explained to him that to control the swing of the crane ball, you had to chase the ball with the jib, keeping the lifting wire perpendicular the whole time. He did his best to control the swing of the ball, but it takes lots of experience, and although he thoroughly enjoyed himself trying to master the technique, we had to move on.

As we walked along the Southern Dock Quay, we saw a big man wearing a leather apron over dungarees. He was waving his finger threateningly at a man in a suit.

'What's going on there?' doctor Smith asked with some concern.

'That big bloke in dungarees is arguing with the other bloke about money for a job his gang have done, or the other bloke wants done,' I replied.

'How do you know that?' quizzed the doctor.

'Well, it's simple,' I said. 'The big chap in dungarees is my brother. The other bloke is the Port Authority Traffic Officer in charge of this quay and transit sheds. If they were arguing about anything other than money, the bloke in the suit would be laying flat on his back by now, and my brother would not be in sight, believe me,'

'Oh!' he said in surprise, 'Really?'

'Yes. Really,' I repeated back at him.

We made our way along the quay onto a West African Conference Line ship that was held off the dock against a pontoon. She was discharging logs over-side under derricks and cranes. The doctor was fascinated by the intricate workings of the steam winches, as they revolved first one way to lift a log from out of the hold, and then were reversed to allow the union purchase to lower the log into a barge. Then it was reversed again to draw the lifting wire from under the log, that was now neatly stowed in a barge, back over the deck and down into the hold some 60 feet below.

He was even more fascinated to watch the quayside crane drivers, gently bouncing logs off the ship's superstructure to turn and steady them, before lowering them slowly into a lighter. He enquired about the bull-winch which, I explained, was used to pull logs into the centre of the hold where a lifting wire could be placed round their middle, so that the union purchase would be more able to lift them directly out of the ship's hold. The idea of getting logs lifted and pulled into the centre of the hold by a 'bull-winch' was introduced by dockers and stevedores in order to speed up the discharging operations, and increase output. Logs, as well as all other cargo discharging operations, were paid on a piecework basis. (The piecework rates for discharging logs varied between four shillings and three half pence, and six shillings and six pence half penny per ton divided among a twelve-handed ship's gang. The piecework rates depended on the type of timber and its density – high rates for soft woods, low rates for hard woods.)

As we made our way along the ship's deck to another hatch, Bob, a Customs Cargo Watcher, met us. Bob had a stiff leg that was strapped in a calliper and an arm that hung loose at his side. Some time before this meeting Bob had asked me how he could get an Inva-car to work as he had to 'bum' lifts off other port employees to get to and from the docks. I had asked him how he had come by his injuries. He told me in the Western Desert in 1942, while serving with the 8th Army. He had also told me he had a 90 per cent war service disability pension. I told him he wouldn't get an Inva-car, and that

he was entitled to and should have been provided with a proper motor vehicle. I asked him if an Army Welfare Officer had been to see him. 'No!' he had said. 'I wasn't aware they had one.' I had taken him to see the Dock Labour Board Welfare Officer, Dan Foley, and although it was not a part of Dan's remit, he was incensed and appalled at the injustice relating to Bob's case. He had taken the matter up with the Services War Pensions Department. I hadn't seen Bob again since I had taken him to see Dan. Now we were about to have a good laugh as Bob related the story of his encounter with a War Pensions Medical Officer.

Bob greeted me on deck with, 'I've been to Cambridge and had a medical.'

'How did it go?' I asked him.

'Unbelievably,' he replied. 'I was picked up from my home, and taken to a Medical Centre in Cambridge by taxi, where I was seen by a Medical Officer who, I reckon, was ninety years old if he was a day. He asked me what was wrong with me. I told him to read my army medical records. He said he'd read them, but he still wanted to know how my injuries occurred. So I told him how I was sitting in the gunner's seat behind the driver in a Bren-gun carrier. It was a lovely sunny warm day, as it quite often is in North Africa. We were cruising along the desert road at about 10 miles an hour, when I heard the noise of aeroplane engines above us. I looked up and there were three German Stuka dive-bombers up there. When I saw them they began to wiggle their wings, and I knew right away they had taken a personal dislike either to my chauffeur or me. Then one of them dived and opened up on us with his machine guns. He killed my driver and shot me through, all the way from my shoulder to my toes. The silly old fool listened to my facetious retort to his questions, gave me a cursory once over, wrote something down on a report sheet, wished me good day, said thank you for coming, and that was the end of my medical examination. I think the crafty old sod was writing a book on his participation in battle zones during the war, and wanted some back-up material to give them authenticity. I don't suppose he'd ever been any further than Aldershot. Anyway, he told me he doubted if I'd be given a car, but he did increase my disability pension to 97 per cent.'

'Did he?' I replied. 'He wasn't all that bad then. That gives you a 100 per cent War Disability Pension. You don't have to worry on the car score now,' I told him. 'Dan will see you get issued with a War Service Disability Vehicle,' and of course Dan did. The whole episode was quite amusing, and even more so when Colin saw Bob's face when I told him, 'Colin is a GP.'

By the time we came off the ship, it was getting near to lunchtime. So I took Colin over to the Port Authority 'Perm's Muster Hut' for a cup of tea. My brother was there with the rest of the freight striking gang, and Colin was quickly involved, chatting to the men; more especially Bob Knight who had avidly studied the Greek philosophers of the first to the third centuries BC. Then a Port Authority Shed Foremen came into the hut, and challenged Colin as to what he was doing there. I told Colin to show him his Port Authority Visitor's Pass. Then my brother waved his thumb at the foreman to beat a hasty retreat. He did.

After leaving the 'Muster Hut', we made our way to a West African Coastal Trading Ship of the Elder Dempster Shipping Line. The ship was berthed further up the dock quay, loading a cargo of cement. Colin asked if he could help the barge hands, and having been told he could, he climbed down into the lighter and stayed for forty minutes. When he came back on the quay he asked the O.S.T. clerk, 'How many tons of cement he had helped to loaded whilst he was in the lighter?'

'Forty tons,' came the reply.

'Forty tons,' Colin repeated, 'we must have earned some money.'

'Forty tons multiplied by four shillings per ton equals one hundred and sixty shillings, divide that between twelve men equals thirteen shillings and four pence for each man,' I said. (That is approximately sixty-seven new pence today.)

'Thirteen shillings and four pence!' said Colin. 'Really! I think I'm better off writing out doctor's prescriptions,' was his honest reply.

'So do I.'

Then he said, 'It's all right doing that job for forty minutes, but fancy having to do it for forty years.'

'Yes,' I told him, 'if you could last that long. But most of these men will be burnt out long before then, or injured, or dead.'

'Yes, I can see that. That's my point exactly,' he agreed.

We had completed a circuit of Tilbury Docks, and left the docks by the Southern Police Gate, close to the Port of London's Ambulance Station. The police officer on duty at the dock gate exit was one of the two police officers that had taken me off a ship to hospital, when I had been injured. He asked me, 'How are you getting on since your accident?'

I think I may have said something like 'OK', before introducing him to Colin, and then explained to him that Colin was my GP.

Colin then casually asked the constable, 'Do you have many men injured in the docks?'

'Yes. We took seventeen men to hospital between 5.00 p.m. and 7.00 p.m. last evening,' the constable informed him.

'Seventeen?' Colin gasped, 'I find that hard to believe.'

'You believe what you like,' was the quick retort. 'We have to pick them up and carry them out.' So they did, the Port Authority police ambulance servicemen, and they were very efficient at their job too, as I well know from personal experience.

Having left the docks, and having bid the police constable farewell, Colin and I made our way to the British Riverside Rail Terminal, walked down the passenger ramp onto the Tilbury Riverside Landing Stage, and boarded a ferryboat to take us to Gravesend on our journey home. I think Colin's day in the docks was a good educational experience for him, both from the physical work side of dock operations, and the type of men the dock labour force was made up of. I think he may also have been surprised too, at the skills employed in the various jobs that were being undertaken. For as he has since pointed out to me: 'Docks are another world, with their own customs and practices, contained as they are behind high walls and fences all around them, that are constantly patrolled by Port Authority police officers, one of whose duties is to keep the 'real world' out. Also how fit, energetic and skilful dockers and stevedores are at their jobs. A mixture of mechanical skills, physical energy, muscular discipline, and more especially watching out for their workmates.'

Of course, few men ever had his opportunity to see the docks working as he did. Even fewer of them would have taken that opportunity to educate or enlighten themselves to the functioning of such a workplace as he did, even if they had been given the chance. He often spoke, and I must say he still speaks to me when I see him, on the subject of his participation in the working processes in the docklands of the Port of London. As far as I am aware, he is unique in undertaking such a diverse experience from that of his own chosen profession. More is the pity.

TALE 17

Them Bones! Them Bones! – Ugh

It was my granddaughter's birthday party. She and her young friends had scoffed all the sandwiches, cakes, and any other morsels of food that had come within the outer limits of their grasps. Now they were slurping up coloured jellies, well laced with various coloured ice creams, from small glass dishes. They were like miniature vacuum cleaners being wielded by pieceworkers, the little cherubs? It was then I remembered back to when as a child. I'd equally enjoyed stuffing myself with the same substance at teatimes on Sunday afternoons, jelly that is. The only difference was, instead of ice cream, my jelly had been doused with a liberal covering of lovely, thick, sweet tasting Libby's condensed milk. My mother always made jellies on Sundays. It was a special treat for us younger ones of her nine children. Jelly, she told us, made strong healthy bones.

However, it was then I remembered why I have never eaten another jelly. It was after one of my experiences in the docks, but before I come to tell you about that tale, I have to further explain. I had worked in ship's holds on many obnoxious cargoes, which were dangerous to the health of human beings. Foremost among these were asbestos, dried blood, wet animal skins and dried hides. Cargoes imported from India, Pakistan, and other Far Eastern countries, and North Africa. The wet skins and dried hides were taken by lorries to be processed at tanneries into leather, as were the crushed bones. Bones packed in sacks on the other-hand, many of which still had generous coverings of muscle, gristle and soft tissue over them, were generally taken by Thames lighters to the import merchant's wharves, further up river from Tilbury docks, to be processed. The skins and hides I had helped to discharge at various times were invariably covered in small black flies, which determinedly settled on one's hands, face, and any other part of the exposed body they could find to land on. Believe me such jobs were both obnoxious, and a danger to the health of the men who had to handle such cargoes. Many men succumbed to diseases such as anthrax, a dangerous cattle disease communicable to human beings, and fungal skin diseases such as ringworm that were undetectable at the time. The flies were always present in perfusion – literally millions of them.

They were horrible, irritating, small black double winged insects that had made the long sea voyage to England sealed inside Clan line, City line, Blue Funnel line, or other Far Eastern trading ship's deep cargo tanks, in a stowage that was designed to keep it from contaminating the rest of the ship's cargo. However, I thought the damn things had made the journey simply to annoy my workmates and me.

I once worked on such a job with a docker who bet me a shilling he could stand being covered in those obnoxious creatures longer than me. We had sent a set of wet skins ashore, and we had made up our next set of skins, and we were waiting for the quay crane to return for another set. During which time he stood absolutely still, while flies covered him from head to foot. He won his bet, but I asked him how he could stand being covered in those damn things. He simply said that in the North African desert during the Second World War, he used to take bets with his 8th Army mates, to see who could

last out the longest while being covered with sand-flies. 'You,' he told me with a broad grin on his face 'were a cinch to be suckered for a shilling.'

Dried hides, mainly those of water buffalo and cattle, as I have previously explained, from which one could catch anthrax, ringworm and other deadly fungal diseases, were regularly imported into Britain from India and other Asian countries by the hundreds of tons. North African countries produced camel hides, and who knows, perhaps even those of the poor donkeys that were, and quite possibly still are, the main mobile transportation vehicles for many of the people in those countries that border the northern shores of the Mediterranean Sea.

When hides and skins arrived in any of the London docks, they were generally still covered in hairs or bristles, among which ticks and maggots could be seen crawling about. As a matter of interest for those readers who doubt the validity of this tale, the 1956 *Port of London Ocean Trades, Piece-Work Rates (Discharging) Price Book*, lists hides and skins thus:

Ship Discharging Gang; 12 men under crane: 12 men under winches plus one pro-rata man winch driver under ship' derricks.

Hides – Dry Bible per hundred. Overside rate – eight shillings and eleven pence (9 old pence per man, or 4.4 new pence per man per ton).

Hides – Dry laid flat per 100 (over half a ton in weight). Overside rate – thirteen shillings and eleven pence (14 old pence per man – 5.8 new pence per man per ton).

Hides – Dry. These rates take·into account the offensive nature of the cargo: Overside rate – seven shillings and six pence half penny (7.5 old pence per man – 3 new pence per man per ton).

Hides – Wet salted – loose or laid flat per 100. Overside rate – twenty shillings and six pence (20.5 old pence per man – 8.5 new pence per man per ton).

Hair – 5 Bales per ton. Overside rate two shillings and five and a half pence (2.5 old pence or 1 new pence per man per ton).

Blood – hundred weight paper bags – Overside rate – three shillings, eleven and a half pence per ton (4 old pence or one and a half new pence per man per ton).

Bone products, i.e. Bones, Bone Meal, Glued Bones, Calcined Bones (bone ash), Tankage Bone Grist (crushed bones), Hoof Grist (crushed hooves), Hoof Meal, Dried Organs, (the price book doesn't state whether mouth or theatre organs') – Overside rate – three shillings, eleven half pence per ton (4 old pence or 1. 5 new pence per ton per man).

Now the reason I have deliberately quoted the discharge price for hides, skins, blood and hair is to give you the reader some idea of the obnoxious types of cargo we dockers and stevedores had to work with, in the normal course of our jobs. In addition, the piecework rates us dockers and stevedores were paid to discharge them from ships.

There were many other imported commodities that brought with them their own miniature and microscopic interlopers, some of them highly dangerous to human beings, and others that were no more than an encumbrance – just a plain nuisance.

For example copra, the dried flesh of coconuts imported from the Pacific Islands, that brings with it what is known as the 'Copra Itch', a skin irritation caused by a mite that attacks mainly the 'private parts' of one's body. (I look back now to those days long ago, when one could see men dressed in old worn out, well patched khaki battle dresses. The uniforms they had brought back with them from the Second World War, standing knee deep in copra, with a huge shovel in one hand, scratching their private parts with the other, and thinking if it wasn't for the way they were dressed, and the place where they were, they look like professional

bowlers at a cricket match, preparing to run up to the wicket.) Rice bran imported from Burma via the port of Rangoon, brought with it its own small 'creepy-crawlies'. That particular commodity, the husks of rice used mainly in cattle food, which also has its uses in some human food products, was brought to the London Docks in ships known to us dockers as 'Shire Boats', simply because the ships themselves were each named after the Shire counties of England. For example the RMS *Gloucestershire* and RMS *Worcestershire*. 'Shire Boats' were cargo passenger liners (which meant they ran on a regular schedule from Burma to London's Tilbury Docks).

The cargoes of rice bran brought to Tilbury Docks in 'Shire boats' were more generally stowed in the 'tween decks, while silver ingots were stacked in the deck's lock-ups with parcels of rubies. Other cargoes such as cut teak timber, teak logs, gum, shellac, lead and copper ingots were carried in the lower holds, generally over-stowing large quantities of iron ore.

When the deck hatch tarpaulins were removed from off the deck hatches, the whole of the deck hatch surfaces were covered by a thick layer of brown crawling weevils – literally millions of them. Weevils are small brown beetles that in Burma, and many other hot climatic countries, are agricultural pests, which we dockers were advised, die quite quickly when they are exposed to the cold.

However, it is obvious that neither the deceased insects, nor their grubs, were ever separated from the rice bran when it was processed into cattle food. So you may be sure that cattle, which are herbivores by nature, were being fed with dead insects bodies and grubs processed in with the rice bran. This was happening long before it was realised animals, when fed on processed offal, chicken manure, and other such animal residue concoctions, developed Bovine Spongiform Encephalopathy – the disease more commonly known today as BSE, or 'mad cow disease'.

You have no doubt noticed, from previous tales I have written, that everything to do with work in the enclosed docks should have began in Dock Labour Compounds, where us dockers should have been picked up for employment by ship workers, quay foremen or gangers. Unfortunately the Dock Workers (Regulation Of Employment) Act 1946, left the whole system of employment in the docks open to corruption. Often more men were 'picked up' for work in pubs, clubs, church halls and Smoky Joe's Café's over night outside of the Dock Labour Board Compounds for doing favours, buying pints of beer, or for being a member of some 'religious, political or other organisation', than were ever selected for employment for their work capability in some dock areas.

However, a stevedore labour contractor's ship worker always 'picked up' the ship's gang I worked with on a regular basis. None of the gang had ever really been employed on a 'dirty job' before, other than myself. They were Royal Mail ship's dockers, more used to loading exported general cargoes that consisted in the main of cases of luxury goods, motor vehicles, and thousands of post office mail bags that were being sent by British families to their emigrated kith and kin in Australia. Or at that time too, sections of space rockets (Blue Streak) and other military hardware destined for the joint British and Australian rocket and guided-weapons range at Woomera, a location in the far outback north of Adelaide. Or discharging imports such as passengers personal effects; bails of wool and bundles of sheep skins; lamb and cattle carcasses; cases of butter; crates of cheese; tins of various fruits and meats; ingots of gold, silver and precious stones; and commodities that were imported worth hundreds of millions of pounds. However, not one of them had ever worked on the discharging of gristle and flesh covered bones. That was till now.

I do have to explain that working with a regular 'ship's gang' for a specific stevedore dock labour contractors ship worker, not only brought its compensations in so far as it at least gave one semi-permanent employment, but as you will see from the contents of this tale, it also brought its pit-falls. As far as our 'ship's gang' were concerned this job was to be one of them. It came to us like a 'bolt out of the blue', because we were aware there was no Pacific & Orient liner due in Tilbury Docks for at least a

week, and Lloyds Shipping List gave no indication of any cargo ships due to arrive in Tilbury docks. So we stood by the 'pick-up' points in the Dock Labour Board Compound waiting for the electronic tannoy system to blare out 'all books in'. When suddenly Charlie S. our ship worker dashed into the Compound, jumped up onto the 'pick-up' platform, and hastily gathering our Attendance Books into his hands said: 'Be at the Riverside Cargo Jetty at one o'clock,' before he jumped down off the 'pick-up' platform and disappeared out through the Dock Labour Compound doorway.

'Christ,' said George our 'down-hold' foreman. 'It's not like our labour master to give us orders for 1.00 p.m. at two minutes to 8.00 a.m. in the morning. I wonder what that crafty lot of sots in the office have got as a nice little surprise for us?' At 1.00 p.m. we found out. All our ship's gang had turned up on Tilbury Cargo Jetty only to find a battered old cargo boat flying one of the many flags of convenience some shipping companies use to get round wage and safety regulations, berthed against the Cargo Jetty. It was on the height of slack water just before the tide began to fall, and the wire springs holding the ship 'fore and aft' were loose, that gave the vessel the look of a beaten up 'prizefighter', who had taken a thrashing, and was holding on to the ropes to save himself.

Charlie S., our ship worker, was already on the Riverside Cargo Jetty when we arrived. He was looking down at the vessel, while talking to Mr Dunlop, the Port Authority's Riverside Cargo Jetty's foreman, but they both clammed up when we descended on them. George got the first words in by saying, 'is that rust bucket down there floating, Charlie, or is my imagination playing tricks on me?' Then he stood scratching his head before saying, 'and where's the crew?'

'Cut out the funny talk, George,' Charlie replied. In an attempt to ignore George's pertinent question, he went on to say, 'Mr Dunlop and me were discussing the unique characteristic of the vessel, and wondered which ship building company constructed her.'

George turned to Terry and asked him, 'Who do you think was responsible for building that monstrosity, Terry?'

Terry, our intellectual university educated trade unionist socialist sympathiser workmate, smiled before he answered. Then he said: 'Well now!' he said as he scratched his head. 'If it had been made of wood, then I should have been prepared to argue it was that biblical fellow by the name of Noah. That theory would have been based entirely on my observance as to its design, construction and general age condition that would put it at about Noah's time period. Of course, Noah's Ark was said to have come to rest on Mt. Ararat according to Genesis 6:4-16, 18-22. But it's obvious by the rust that's flaking off every conceivable part of that, dare I say, floating conundrum, the damn things obviously been constructed of some inferior steel alloy. So by the simple ruse of elimination, Noah can't be blamed for putting together that floating abomination.'

'Cut out the cackle and get your down-holders aboard that shit, I mean ship,' Charlie said quickly correcting himself. 'Mr Dunlop has refused to allow us to stow the ship's cargo in the jetty's cargo bays, but we can land it on the jetty to transfer it into lighters. The lighters are already laying on the slack water inside the jetty. I've sent a message to the Dock Labour Board to let me have another crane driver for the shore-side jetty crane, and a "change-over man" for the jetty. The O.S.T. clerk is posted ready for you lot to start work, that's as soon as the other two men turn up. So let's be having you, get those hatches and beams off, this ship is due to sail on the next flood tied – you're on a job and finish.'

'What's the cargo and how much is there of it, Charlie?' George asked.

'Bones George, and there's only a 150 tons of them. You should easily finish the job by eight or nine o'clock tonight and you'll have tomorrow off.' He then dashed off the Riverside Cargo Jetty, and made his way towards the stevedore labour contractor's riverside office, where he could wait in safety till the next phase of this saga was over.

'Come on, lads,' George ordered the ship's gang, 'let's go and see what sort of mess Charlie's got us into this time,' and they all made their way slowly but purposely down the ship's gangway (as surely as they had made their way during the Second World War, from the beaches of Dunkirk, across the sands of the Western Desert in North Africa, through Sicily, up through Italy and Austria, into Germany), to unbuckle the steel bars which held the hatch cover tarpaulins in place, before taking off the hatches ready to undertake what was to be the grisly task of discharging the ship's cargo of bones. In the meantime, I clambered up the steel ladder into the crane's cabin, and swung the jib out over the ship to pick up the beam legs. (Beam legs were a long pair of wires, joined in the centre to a steel ring, with toggles on each end with which to remove the ship's hatch beams and sister beams).

However, once the tarpaulins had been removed and the hatch covers exposed to daylight a roar of anger was heard from the 'down-holders' with the sight that met their eyes. For crawling along between the ship's combing and the hatch covers were very large white maggots, and I do mean large, almost the size of caterpillars. They were so big, in fact, I could see them quite plainly crawling about on the deck hatches from my lofty perch and safe haven in the crane's cabin, high above the ship's deck.

'Why! Those crafty bastards,' said George, 'if this is what's showing above hatches, I dare to wonder what's under them. Don't touch anything, I'm going to have a word with that lot in the office,' and with those last words he made his way up the ship's gangway onto the Cargo Jetty, on his way for a real verbal 'punch-up' with Charlie and his cohorts, who were sitting in the relatively plush comfort of their office.

In the meantime, with nothing to do, I came down out of the crane and walked down the gangway onto the ship's deck. Terry was standing by the unopened hatch flicking maggots with his index finger and thumb, one after another, obviously bored to tears, while the rest of the gang were leaning against the ship's rail staring at the river, looking sullen and talking in low mumbling voices. It was like being beside a volcano that was ready to erupt.

I said to Terry, 'It's a pity we've got no fishermen in the gang, there's a nice lot of bait here.' Terry did not respond to my friendly overtures, but Brains our 'tea-boy', who most of the gang thought was just a few brain cells above being an idiot, and who was standing close to Terry asked, 'What are maggots, Terry?'

Now I have to point this out, because it's always baffled me, why there was always a close affinity between Terry, our clever and knowledgeable university graduate workmate, and Brains our dumb, almost imbecilic workmate. It was as though they were a double act, with Brains asking the questions, and Terry providing the answers.

Terry flicked another maggot across the deck hatches before he made a reply. Then he said: 'Maggots, my old friend, are the legless larvae of flies or bluebottles. Flies or bluebottles lay eggs in food or waste products. When the eggs hatch, the larvae or grubs as they are sometimes called, feed off of whatsoever they are born in. In the case of these maggots,' Terry flicked another maggot across the hatches then continued, 'have been having a field day. The eggs from which the maggots have hatched, were laid in the flesh and gristle on the bones down there, before or when they were being loaded,' he pointed his finger at the wooden hatch covers, 'where it's warm. There must be plenty of meat on the bones for the maggots to have grown that size. Do you know, Brains, we're going to get a shock, when we take those hatches off.'

It was at this juncture that George came hurrying back along the jetty, followed by the ship's gearer pushing a wheel barrow, on which were a dozen boiler suits, Wellington boots, and rubber gloves, which he promptly threw down off the jetty onto the ship's deck. He did this while George made his way down the ship's gangway, waving a piece of paper and smiling, as Neville Chamberlain (1869-1940)

had smiled when he returned from Munich after concluding the Munich Agreement with Adolf Hitler (1889-1945), an agreement which turned out to be just about successful in its outcome as events turned out, before boasting: 'I've had a right go at that lot in the office. I told them about the maggots crawling up between the deck hatches and the hatch combing, and that we were not taking the hatches off till we were guaranteed an enhanced 'price for the job'. The Charge Clerk telephoned through to the shipping company's agent who authorised the payment of a Short Night (payment till midnight) and a five pounds bonus on top of our piecework earnings, so now you can take the hatches off and we can get to work.'

'Hold on, George,' said Terry. 'Where's this ship come from, do you know?'

'Burma,' replied George. 'Why?'

'Well, she's drawing a lot of water with a 'tween deck full of bones. What's she got in the lower hold?'

'Iron ore as far as I know, that she picked up in Rangoon.'

'So where did she pick up the bones?'

'The manifest states Bengal. Why?'

'Let's get the hatches and beams off, then we'll see just what sort of animal bones they are, and with the size of these maggots crawling about, what sort of condition they're in,' Terry replied.

With that comment ringing in my ears I left the ship, went up onto the jetty, climbed up into the crane's cabin, and swung the jib back over the ship from where I watched the ship's gang gingerly lift off the wooden hatch covers. When the hatch covers were removed, it revealed a mass of maggots crawling in every direction over rotting sacks of bones. The bones were still covered in soft tissue, gristle, and an oozing liquid of a yellowish/greenish hue. 'Christ' I said to myself, 'thank heaven I've not got to go and work among that lot.' It was then I heard the first raucous cries of seagulls, and looking up I saw there was a veritable flock of them circling above the ship. I immediately hoisted the crane ball and swung the jib back over the jetty, then quickly scaled my way down the ladder, onto the ship's deck.

'What are you doing down here?' said George. 'Get back up in that crane and take the ship's beams off.'

'Sod the ship's beams, George,' I told him. 'You lot don't want to go into that bloody horrible mess. Tell Brains to make a pot of tea, and while we're having an early tea-break, let the seagulls come down and have a feast of those maggots.'

'That's a bloody good idea, mate,' he said, then turning to Terry he asked, 'and why didn't you think of that?'

Terry then said, 'I was just waiting to see how long it would take you to work that problem out, George. After all, you're in charge, you should know something.'

George smiled, waved his fist at Terry and said, 'what! Wear my brain out when I've got you, don't be so damn stupid.' Then he told the rest of the gang, 'Clear the decks and let the gulls get to work. Henry thinks those hungry perishes up there will clear most of those maggots up, while we are having our tea-break.'

Sure enough, even before the 'down-holders' moved away from the deck combing and went aft towards the ship's galley, the gulls had descended in droves onto the exposed cargo. Where they continued screeching raucously, pecked viciously at each other, while the gluttonous squabbling mass of aerial yobbos (winged yeggs that will snuffle up anything in the food line that's on offer) were flapping their wings while gorging themselves not only on the maggots, but also on the soft tissue, muscle and gristle left on the exposed bones. We stood on the ship's deck watching them in the ecstasy of their revelry, as they fumbled, tumbled, screeched, flapped their wings, spat at each other, rose in the air before making short circuits of the hatch, till George said: 'That's enough, lads. We'd better start work before that greedy flock of sods eat all the

cargo.' However, by the time the gang started work discharging the bones, the whole of the top layer of sacks were covered in a layer of white sticky guano, which brought not a few lurid comments, the best of which I thought was, 'Gowd blimey, they've turned it into an ice rink. I don't know what's the worse, the maggots or the seagull crap.'

As I went to walk away, making my way towards the ship's gangway, Terry stopped me: 'What made you think of letting the seagulls come down and clear the maggots?' he asked me.

'The Mormons,' I replied.

'Where do the Mormons come into this "unsolicited flash of brilliance" on your part, that must have almost caused you to have a brain-storm?' he joked. Well! I think he was joking?

'Terry!' I exclaimed in surprise, 'you must have heard of a bloke called Brigham Young, the US religious leader of the Church of Jesus of Latter-day Saints. Brigham Young took over the leadership of the Mormons when Joseph Smith, the Mormon Church founder, was killed by a mob in Illinois, in 1844. It was Brigham Young who led his disciples across the American prairies, till they came to a place called 'Salt Lake City,' where they stopped and planted crops. Mormon Legend has it that the crops became blighted with caterpillars or maggots, and that flocks of sea gulls came and ate the pests, so saving the crops. I was told that the Mormon emblem is that of a seagull. That's why I suggested letting the gulls have a go at clearing up our unwanted maggots.' Then I said, 'Surely you must have heard the story of the Mormon Migration by wagon train across America, Terry?'

Terry shrugged his broad shoulders, 'Karl Marx exposed religion for what it is. The opium of the minds of susceptible people. Witch doctors among tribes of cannibals get the same sort of results, tooting out the same sort of hullabaloo to tribesmen who've never heard of God. I am an atheist. I'll have no truck with religion.'

'Well,' I told him, 'Karl Marx was wrong on that one, wasn't he. The opium of the people is ignorance brought about by lack of formal education, coupled with the implantation of anti-social parasites in the minds of susceptible people, mainly the young, for the benefit of religious or political organisations. George,' I told Terry, 'almost got his first laugh at your expense. It was a good job I saved your bacon, wasn't it. You'd never have lived it down.'

It was then that George's Sergeant Major's shrill voice carried along the deck with: 'Get up in that bloody crane, there's three sets of bones waiting to be lifted onto the jetty.'

I put two fingers up to him, but quickly got on my way because I knew from personal experience the lads wouldn't want to be stuck in that water-born, maggot infested, guano covered bone-yard for longer than was necessary. But when I had got back in the crane's cabin and brought the jib over the open hatch I couldn't resist calling out:

'George, from where I am up here, that stowage looks like an iced Christmas cake, covered as it is in seagull guano,' but all I got as a returned message from him was a wave of a huge fist that had often connected with jaws that contained foolish talking tongues, so I put into practice that old saying, 'a still tongue keeps a wise head.' After all, I am writing about the docks, not a children's puppet show. However, even though I had begun to lift sets of bone sacks out of the 'tween deck hatch, to land them on the cargo jetty, the seagulls still went on swooping down on the maggots and morsels of flesh that fell from the sets.

Then, at six o'clock, I saw Brains make his way to the ship's galley, to scrounge some hot water to make a pot of tea. A few minutes later George crossed his index fingers in the shape of a 'T', indicating to me to come down on deck for a tea break.

None of the gang was talking, they stood about sipping from their mugs of tea, till I asked: 'Terry, do bones carry disease?'

'Why do you ask that question?' he said.

'Because when I've brought the crane over the ship on several occasions, I've seen you studying loose bones that have fallen out of those rotten sacks.'

'Well,' he said, 'as a matter of fact many of them do carry disease.'

'How do you know?' said George.

'Because when I was studying at university, I spent a furlough on an archaeological dig with the university archaeologists.'

'What's a furlough, Terry?' Brains asked.

'It means a "leave of absence", a change of work commitment, that sort of thing.'

'Bloody shirking, more than likely,' said George.

'Ah!' said Terry, 'that's why we've got this job digging up these bones, is it. So the gang can do a bit of shirking.'

'Oh, get on with your tale if you're going to,' said George, 'it's probably only communist propaganda anyway.'

Terry smiled and shook his head, and then he continued: 'You asked me if bones carry disease, and the short answer to that question is, yes they do. What's more disease lingers on in bones for hundreds of years. One of the 'digger's' working with me pricked his finger on a piece of bone that came from the skeleton of a Saxon who had died in the seventh century AD. The digger's arm turned yellow. It turned out the bones of the skeleton were infected with a disease known only to be prevalent in Saxon invaders from North Germany and Denmark.'

'Christ!' said George, 'do you mean to say these bones could be contaminated with disease?'

'Yes, they most certainly could,' said Terry, 'but it's not only bones that carry disease, so does flesh. Now if I remember correctly it was Louis Pasteur, a French chemist, whose work on fermentation led to the science of bacteriology. It was his investigation into infectious diseases that led to the discovery of anthrax, a deadly cattle disease that can be transmitted to human beings by skin contact, or even by inhaling contaminated dust from infected hides or wool. But the point I want to raise is Pasteur also discovered that animals which had been infected with anthrax, when they had been slaughtered and buried, the anthrax virus laid dormant in the soil, which then contaminated the next lot of animals that were set to graze over the previous animals' graves, or pastures.'

'Are you saying these bones could be that dangerous,' said George.

'Yes, but not only that,' said Terry, 'it's recently been discovered too, that cattle bones from imported South American beef carries with them 'foot and mouth' disease. When I was on my archaeological dig, the Orthopaedic Archaeologists made a number of discoveries relating to injuries and diseases in ancient skeletons, but to my own knowledge their findings have never been made public.'

'Why not?' said Brains.

'I've no idea,' said Terry, 'but I will tell you this. Lots of the bones in this consignment come from human skeletons. Scientists have suspected for some time that imported bones coming from the Far East, especially those loaded at Bengal, contain human parts. That was why I asked George where this consignment had come from.'

'Do you mean to tell us the authorities know what's going on, and do nothing to stop the trade?' said George.

'I suppose the British government doesn't want to upset Asian governments, or British importers of this onerous trade. But don't forget its big business for some, and a diabolically dangerous and filthy livelihood for others. The river Ganges is a veritable gold mine for bone collectors.'

'Damn you Terry,' said George, 'let's all get back to work and finish this poxy job, before we lose our nerve.' And the ship's gang clambered their way down into the filth and stench of the 'tween deck, as I made my way up into the fresh air high above their heads.

We worked on till ten o'clock that night before we finished discharging the bones. Seagulls were still scavenging about on top of the jetty in semi-darkness, even after I had replaced the ship's beams, and the lads had covered up the hatch, and left the ship. I stood and watched as the loaded lighters of bones were being towed away up river, followed by a large flock of raucously screaming seagulls, to be taken for processing into whatever was made out of them, no doubt in some dingy back street factory, set among the hovels of London's East End.

I had come down out of the jetty crane, just as the ship's gang came ashore. We were walking away from the ship along the cargo jetty towards the steel cat-walk bridge, a contraption that connected the Riverside Cargo Jetty to the sea-wall outside the dock perimeter boundary. Terry and Brains were tagging along behind the rest, stinking to high heavens like a pair of skunks that have just emerged from a cesspit, with their overalls covered in seagull guano, crushed maggots and pieces of putrid meat tissue, carrying the gang's 'tea-box' between them. This gave me the opportunity to ask: 'Where do those bones go now, Terry? What do they do with them?'

'They're processed into animal feed stock, agricultural fertiliser, glue and *jellies*.'

That's as far as he got. I rushed away from them to the edge of the jetty, and puked.

'What's wrong with him?' I heard Brains ask Terry as they walked away from me.

Terry laughed before he answered, then he said, 'Got a weak stomach I suppose. There's a lot of crane drivers like that you know, bloody gutless.'

I have to tell you now that Terry was right. I had just ejected the contents of my stomach into the already murky water of the river Thames. Whether Terry was telling the truth, or just joking about the manufacture of jellies I never found out, but I've never eaten another jelly during the rest of my life, with or without Libby's condensed milk. Them Bones! Them Bones! – Ugh.

Postscript

Since I have written this story of 'Them bones! Them bones!' New Research Focus, published by the University of Kent at Canterbury Alumni Magazine, contained an interesting article based on an interview with the British Broadcasting Corporation (BBC) by Alan Colchester, who stated: 'There is a whole range of public health concerns over the (river) Ganges pollution. But amongst all the recognition of potential problems I don't think anyone has thought about the very rare, but very important risk, posed by the corpse of someone who has died from a version of CJD.'

I have to point out that Terry, our university educated dock labourer, did think about such problems at the time such bones were being imported fifty years ago. However, in those days no one would listen to the views of a dock labourer, no matter how well educated he was. However, maybe researchers will take some notice of Professor Alan Colchester's comments on a very serious subject of 'Them bones! Them bones!' – imports from the Far East including the river Ganges, and other such places in India, Pakistan and Bangladesh. From those places nearly 50 per cent of all British raw bone imports are reported to come from during the 1960s and 1970s. Professor Colchester can take it from me also, raw bone imports were being brought into Britain in the 1950s too. That is the period in which this tale evolved, although it's taken me almost sixty years to get round to writing about it.

TALE 18
Lucky Escapes from Dock Working Injuries

'Jesus Christ, Harry!' I heard Wally's voice cry out, 'I think you've squashed him? He must be dead, buried under that lot.'

Work within the port transport industry was dangerous. Many accidents and near miss accidents happen in the most extraordinary circumstances, some of which could be quite funny. Other accidents, as I was to find out from personal experience on more than one occasion, were not so funny. There were not only accidents that happened to myself, but accidents and injuries that also happened to my workmates.

One particular occasion occurred when I was working with a striking gang, soon after I began my employment in London's docklands as a docker. (A striking gang was made up of dockers and/or stevedores who unloaded freight from lorries or rail trucks, which was housed in transit sheds or warehouses ready for shipment as cargo in deep sea trading vessels or short sea traders, to foreign lands all over the world.) The gang was made up of eight men, two men whose job it was to 'break out' (separate the various items of cargo) and load them onto hand propelled wheel barrows, and six men whose jobs were to trundle the heavy loads into allocated stowage's in a warehouse or transit shed, ready to be exported.

On the day of this particular tale our striking gang that was discharging freight from rail trucks saw my workmate, a new recruit like myself, trying to manoeuvre a toe-board from the loading bay at the rear of a transit shed into a rail truck's open doorway. When he let the toe-board drop it crashed down onto his feet and broke his toes. Of course the Port Authority blood wagon was called for, which whipped him off to hospital, where his feet were encased in plaster of Paris. That accident was a stupidly self-inflicted injury, by an inexperienced workman.

On another occasion I was talked into volunteering one afternoon for work on a West African trading vessel. The ship worker told me there was only 50 tons of rubber to be discharged, a job that in normal circumstances should have taken no more than a couple of hours. When I arrived on the discharging vessel I discovered the 50 tons of rubber (swamp rubber as it turned out, which stank to high heavens) had vulcanised itself into a 50 ton solid block. Me being a crane driver, I had no reason to be carrying a docker's hook, so I borrowed a workmate's. Unfortunately Jimmy (whose hook I had borrowed), was standing directly behind me when I tugged at one of the bales. The hook came away from the bale so that the back of my hand smashed into Jimmy's face, breaking his nose. That was an unintended accident caused by one workmate on another.

Then there was the case of a workmate who was operating in a ship's hold making up a set of groundnuts. The union purchase (lifting hook attached to two wires running from the winch drums) that had been hanging over his head suddenly, without warning, dropped on him causing severe head injuries. It was argued in the ensuing court case, brought by a trade union on behalf of its member for

compensation, by the shipping company's defence team that there had been a loose turn of wire on the winch drum that had caused the union purchase to drop, without any human involvement. Therefore, they had stated, the accident was an 'Act of God' over which their client had had no control. Well! They would argue that as a defence for faulty equipment wouldn't they. However, the judge hearing the case, after having been advised by his clerk, who had herself been advised by a docker/winch driver witness, what a winch drum was, and how when it revolved it acted in the same way as when the cotton on a bobbin in a sewing machine was wound on from a cotton reel, came to a different conclusion than that of the 'Act of God' argument put forward as a defence by the legal team acting on behalf of the shipping company. He found in favour of the plaintiff.

Another laughable accident that springs to mind was when I was driving a 'goose necked crane', discharging three hundredweight sacks of Tate & Lyle raw imported sugar from a freighter. The crane was a pre-war (pre-First World War crane that is) worn out mechanical contraption that had a large peddle for lowering the crane hook, and a long lever for raising it. The barge hands had unhooked a set of sugar and waved to me to take the crane hook away, which I did by yanking on the raise lever. The next thing I knew as I looked out of the crane cabin window was that one of the barge hands was dangling on the end of the hook by his trouser belt, with his arms and legs spread out like a parachutist doing a 'free-fall' stunt, while glaring at me in a not very pleasing manner. I quickly lowered him back into the relative safety of the barge, to the cheering of his other three workmates, and a somewhat lengthy cascade of verbal abuse from his not so pleased good self. At least the barge hands thought it funny. Well they would think it was something comical as it hadn't happened to them. Well! Wouldn't they?

Now I come to what turned out to be the last comic accident that happened to me, before the real thing came close to robbing me of my life. For as I have already stated, I heard Wally our down hold foreman's voice cry out:

'Jesus Christ, Harry! I think you've squashed him. He must be dead under there?'

Like the rest of our ship's gang I had been picked up by Harry, a stevedoring company's 'top-hand/ganger', in the Dock Labour Compound that very morning, to help in the loading of a freighter. The ship, already partly loaded, had arrived in Tilbury docks from Holland on her outward journey to Jakarta, on the island of Java in the former Dutch East Indies (Batavia, capital of Indonesia). Her lower hold and most of her lower 'tween deck were filled with cargo, freight that had been shipped in the port of Rotterdam. However, there was cargo space in the lower 'tween deck under and between the ship's beams, for quite a bit of general cargo. Therefore our first job after taking off the deck beams and hatches was to strip off the upper 'tween decks hatches, to make ready for stowing sets of general cargo (cases, crates and cartons) that were to be brought out of the transit shed on wheel barrows by a port authority quay gang.

Unfortunately, there was no port authority quay gang available to trundle the topping up cargo out of the transit shed onto the quay loading pitch. However, we were told the Dock Labour Board had indented for a gang of stevedores. They were to be sent down from one of the London docks. So, we were assured by the ship worker in charge of the vessel that the men were already on their way. However, we knew from experience they could not arrive for at least two hours if they came by train. So, in the meantime we were obliged to work out of a Thames' lighter, 'over-side' under the ship's winches, which had a freight of Fuller's earth. (Fuller's earth is a clay-like substance when wetted. Otherwise when dry, it is a powder form that contains Silica. It is used in removing oil and grease from wool, (a process known as fullering). It is also used to bleach petroleum products, in refining vegetable oils, and many other similar products.)

A group of Royal Engineer divers helping to build Hong Kong Harbour, *c.* 1890s.

Gravesend town pier with British Rail (BR) steam ferry *Catherine*. Also, in the background tugs of William Watkins fleet awaiting orders, *c.* 1930s.

We began loading the Fuller's earth by building a landing stage. We did this simply by landing two sets of the stuff onto the steel deck either side of the open hatch, and placing a wooden deck hatch on top of the sets to make a platform. Then when a set had been landed, the bags were carried on our backs into the ship's wings where they were stowed for the duration of the voyage. We started on our backs, but in fact not on my back, because I was nominated to be the chap who slid the sacks off the sets so that my workmates could grab the sacks' 'ears' and lugg them out to the stowage points in the wings of the ship.

The job had been going quite well until 'Beer Ho'. That was when the up and down winch driver began to complain his winch, which was steam powered, was playing up. Several times he had stopped the job to get a ship's engineer to look at it, but other than squirting some oil on the piston rod, and using a pressure pump to force grease into the grease nipples attached to the winch casing, the Dutch engineer obviously felt disinclined to take any further action. This was possibly because the winch required stripping down, so that the piston could be repacked to prevent further loss of power. It was a job that could wait, as far as the engineer was concerned, till the ship was at sea. He would not, if it could be possibly avoided, waste valuable freight loading time, as the ship was due to sail in a couple of days. So he went on fiddling about with that obsolescent contraption, trying to keep it going all the time it was still working, even if it was somewhat erratic, as it puffed and farted like an over-weight jogger in an over-eighties road race.

Harry, our top-hand/ganger, was in a quandary. He wasn't a man to be easily flummoxed. He was a former Royal Engineer under-water diver, and had worked on the building of Hong Kong harbour in the latter part of the nineteenth century. Now in his seventies, he was still agile and fully mentally alert, but he failed to understand the significance of the jerky action of the up and down winch. It therefore came as a complete surprise to him when a set of Fuller's earth, that had been raised up from the lighter, dropped like a bomb onto the deck hatch on which I was working. I must say, I've no recollection of how I arrived some 30 feet away from the landing board I'd been standing on, when that rouge set of Fuller's earth struck the wooden hatch cover. When I landed I was laying on some lengths of steel girders, where I had been catapulted like a circus acrobat who had been fired from a cannon, and had unfortunately missed the safety net, as the set of Fuller's earth crashed down onto the unsupported end of the wooden hatch cover that had been acting as a landing board. When I looked up I could see my workmates scrambling among a dust storm, created by a pile of ripped sacks of Fuller's earth, searching for me. I can still hear Wally's voice as clear today as I heard it all those years ago shouting:

'Jesus Christ, Harry! I think you've squashed him? He must be dead, buried under that lot.'

But all of my workmates turned towards me in utter amazement and surprise, when I called out to them from my newly acquired vantage spot: 'I'm all right I think? I'm over here.'

I had been miraculously shot over the top of the open upper 'tween deck hatch onto a consignment of previously loaded steel girders, some 20 or 30 feet away from the deck hatch on which I had been standing, and from which I'd taken off. I had suffered no injury whatsoever – not even a scratch. That was a close call to serious injury if ever there was one. I wasn't always to be so lucky, when I finally came to grief some time later. The injuries of that accident would be with me from then on, till the day I die.